Bent Objects

The Secret Life of Everyday Things

by Terry Border

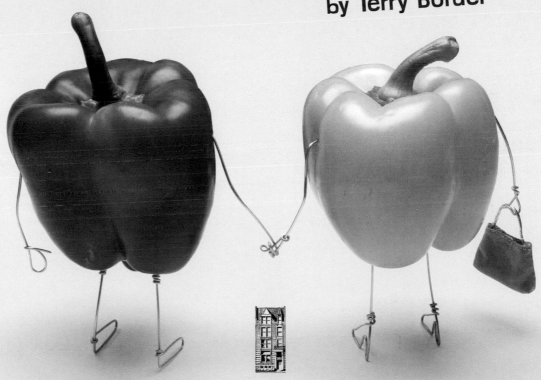

RUNNING PRESS

PHILADELPHIA · LONDON

9 8 7 6 5 4 3 2

Digit on the right indicates the number of this printing
Library of Congress Control Number: 2009923122
ISBN 978-0-7624-3562-3

Cover and interior design by Jason Kayser
Typography: Chronicle and Imperfect

Running Press Book Publishers
2300 Chestnut Street
Philadelphia, PA 19103-4371

Visit us on the web!
www.runningpress.com

DEDICATION

This book is for the three women of my life: my wife Judi, who is my partner in the creative process (and is the real professional artist in the family); my mother, who always encouraged me, no matter what I did; and my fantastic daughter, who helps keep me young in spirit.

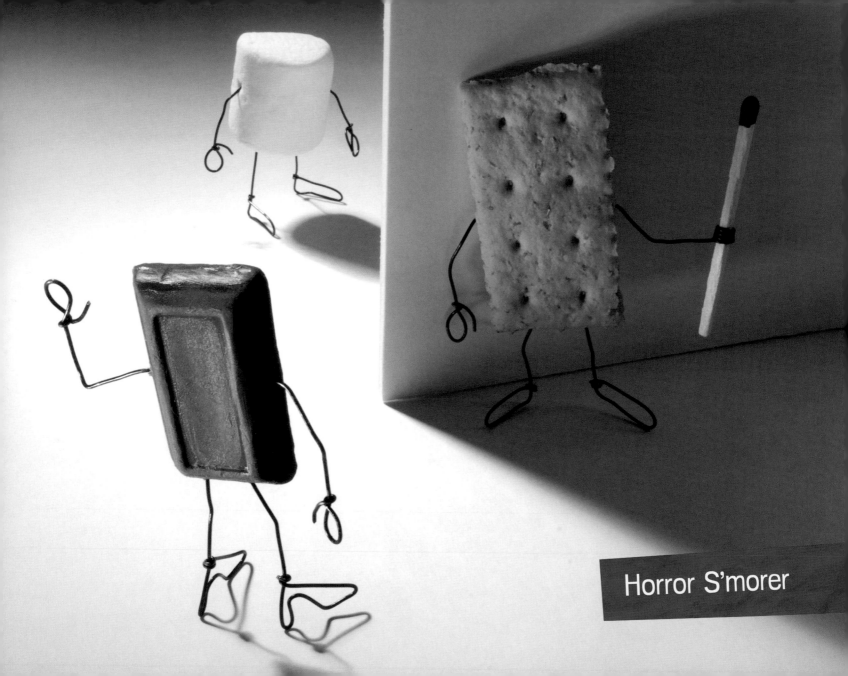

Horror S'morer

AN INTRODUCTION

WHEN I WAS EIGHT OR NINE YEARS OLD, I would sit between my parents and grandparents during church services on Sunday mornings and Sunday evenings. It was my job to just keep quiet and not bring any attention to myself during those long sermons. With no paper to draw on, and not any interesting reading material, I used my imagination. I would find faces and figures in the pattern of the wood-grain pew in front of me. I'd look in the pattern of the carpet below my feet and see the shapes of monsters and animals. I'd arrange my fingers in such a way to make characters that would talk back and forth between left hand and right. Doesn't sound very fun, but at the time it was all I could come up with. Today, I still see different things in the mundane objects that surround us.

Whenever I've looked at a pair of scissors, they've always appeared to me as the head and beak of a strange-looking bird. When I add on some wire to make the bird's body, I'm just filling out what my imagination already sees. Then when someone else sees what I've done with the scissors, they might say, "Yes, that's what I've always imagined scissors as too!" or, "Hey, scissors *do* look like a bird, don't they?" It's great when we can share a discovery or thought about some ordinary object that we all see, but usually don't pay much attention to.

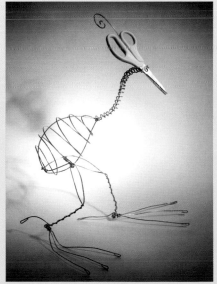

Someone once said that art makes the invisible visible, and that's where the fun is for me. If I can take an ordinary object, add a little wire to help draw in what I'm already imagining, and then have people recognize it, that's enjoyable for me. But what if I'm able to show what kind of life this character is leading, and maybe what kind of feelings we may have in common with that character? *That's* when I feel that I've truly been successful. I've made the viewer sympathetic to something that was pretty much invisible to them up until that point (plus I get to show how clever I can be, which is what most artists want to show the world anyway.)

Beginnings

One day on a lark, I picked up a coil of old black wire that had been lying in our basement. I'd brought it home a few years earlier when we cleared out my late grandfather's home. Instead of me doing something useful around the house (like cleaning the basement), I started bending the wire, making little shapes, and writing names with it. It was sort of interesting, and I kept bending on and off for a number of years. I became pretty good at it, but I rarely included these little wire pieces in gallery shows I was invited to be in to show my other, larger work. As I saw it, it was too hard to focus your eyes on these little, airy wire pieces. If they were in front of a busy background they became almost invisible.

That was until one day when I decided for one reason or another to use a small pencil for the body of a little bug shape that I was working on. I liked the little bugger so much that I made another bug using part of a paintbrush as its body. Like the pencil bug, I used wire for the legs, wings, and antennae. Those two little creatures proved surprisingly popular when friends from an internet art group saw them. I quickly realized that *any* object could be combined with some wire to create some sort of character, and, more interesting for me, could be used to interpret an idea.

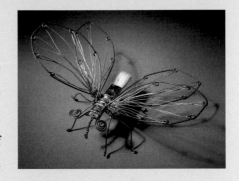

I started an internet blog for my new object-plus-wire direction, but many of the names that I came up with were already taken. I finally settled on Bent Objects because I was bending wire around objects, and my ideas are usually a little twisted, i.e. bent.

Because I had been in commercial photography for several years, I had a lot of photo experience, but I was pretty much burnt out on it. Photographing other peoples' layouts was something I didn't find much fun in doing. Though I had spent several years assisting some really great photographers and had learned quite a few tricks, I considered photography a necessary evil in order to post my little pieces on the internet. I was hoping that I'd start to sell some of my works through an online store, but then something funny happened—people were more interested in the *photos* than the real sculptures. They started asking for prints and calendars. That threw me for a little bit of a loop, because I had gotten out of photography almost five years previous, and was very happy being out of it. After a little thinking though, I realized that these images would be entirely my ideas, so what the heck, I *could* have fun with it! I decided that the end product of my imaginings would in fact be photographs and not the sculptures themselves. If I found something I could enjoy creating, and that other people would enjoy too, then I'd better darn well do it!

When my focus changed from creating sculptures to creating images, the big change was that I didn't need to make the physical pieces durable enough to be exhibited in a gallery, or to be sent in the mail to a buyer. I just needed the characters and/or scenes to stay together long enough to photograph. Now I could use absolutely anything as materials for my imaginings, including short-life objects like ice cubes, burning candles, and food right out of our refrigerator. Grocery stores became warehouses chock full of objects just waiting for me to use them in an image. Hot dogs, cheese doodles, and peanuts are a few that I've used over and over again.

How do I come up with ideas?

People ask how I come up with ideas for images. I'm like anyone else that comes up with ideas in that there isn't just one answer for that question. Sometimes we'll be walking through a store and I'll see an object that will remind me of something else. Or we'll be in the kitchen making hot cocoa and I'll think about the life of a marshmallow and its gruesome ending in the scalding (but tasty!) hot chocolate.

I get ideas for images by imagining what a particular object's *life* would be like. How would they go about their day? How do they relate to others? What would they do for a living, and then what do they do on their day off? All kinds of questions and imaginings go into it. I'll put whatever object I'm working with in front of me. I study it, research it, and generally think about it until my head hurts! Hopefully, after all this thinking, my subconscious mind will put all the pieces together for me and the idea will come to me. It's been my experience that my subconscious mind is a lot better at problem solving than my conscious self. But it acts on its own schedule, and you can't hurry it along much. After thinking awhile in a certain direction, I take a break and think about something else.

If I've been reading a book, an image might come to me that relates back to the object. If I'm looking at art books before I go to sleep, I might wake up thinking about what Michelangelo would do with a cheese doodle. Everything is fair game, no matter how weird. In fact, the weirder the better is how people seem to like my work. I do a lot of reading, do a lot of listening to people, and watch lots of movies—I never know what is going to trigger an idea. (That's what I tell my wife anyway when she sees me doing not much of anything—which is the majority of the time!)

Once, as I was walking through the produce section of our grocery store, I saw a basket full of beautiful fresh yellow lemons. In the basket right next to them was a bunch of those plastic lemons containing lemon juice. I started wondering what the relationship between them would be. Real versus plastic. You could say that the

plastic ones would be like mannequins, or dolls, but the fake lemons are life-size dolls compared to the lemons. As I took this line of thinking further, I figured that it would be kinda embarrassing for a lemon to be caught with a plastic lemon, but a *lonely* lemon might order one through the mail, as long is it came in a plain brown wrapper. I then made the little set to place them in, and I bought a tiny wooden dollhouse chair, for him to lean up against the door.

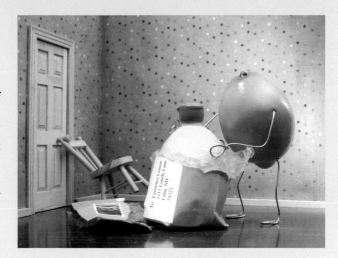

Basically, I look at an object and am reminded of something else. I ask myself what's funny or interesting about that. I add some wire arms, or legs, or whatever it takes show others what I was thinking. Then it's all about posing the character, deciding on a background, and lighting the scene. Click the camera's shutter, and there you go—a Bent Objects image!

Sometimes there are different levels of meaning to the images. Sometimes there's more than just the immediate laugh that you see on the surface. I'm not disappointed very much if people don't go looking for anything deeper. I only hope that everyone enjoys the images that we've collected for this book. That's what I make them for!

Terry Border

9

MONEY IS NO OBJECT

(Unless You Make It One)

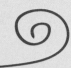

I've heard people say, "When I get the spare bedroom cleaned out and turned into a little studio, I'm going to work on some watercolors." Or "When I can afford to take some lessons, I'm going to learn how to draw." There are many photographers who think that if they just had a better camera, or better lighting system, then they could make some great images. Of course it's great to have a room dedicated to your creativity, and it's usually a good idea to get some instruction from someone more experienced. The better tools you have to work with (like quality paintbrushes, or a top-of-the-line camera), the easier some jobs can be. What I'd like my images to be, though, are examples of how a person can create something with stuff that's already all around us.

For example, I doodle in all kinds of sketchbooks, but my doodling doesn't get any better by using more expensive paper. Many times, I've used desk lamps and flashlights to light my scenes to be photographed. The first half of this book was shot using an everyday, pocket-sized, digital camera. I buy my wire from hardware stores, and people found me on the internet courtesy of a blog that didn't cost me a cent to set up.

Photography, a field that I've kind of fallen back into with my current work, has a lot of people who spend lots of time testing lenses, studying processes, debating which is the best technical gadget. From what I've seen, they rarely *create* much. I would compare them to people who like to collect cars, but don't know how to race them. Instead of just going out and doing it, they spend their lives getting ready.

I started working with wire several years ago, then I moved on to bigger materials for bigger sculptures. It got rather expensive, and as I look back on it, even though my work became larger, it didn't get better. My unsold work began gathering around our house, and I became the biggest collector of Terry Border art. I guess I thought I'd be taken more seriously if my work was too big to ignore. I learned a couple of things though: 1) I didn't really like to be taken "seriously," and 2) it's the thought that counts (meaning the thought behind a work). Bigger isn't necessarily better (after all, a roll of wire is rather small, but I know how to use it!)

After I realized that the *concept* mattered over the size, I started using wire again, but this time I worked small so I could throw away my mistakes, and put whatever didn't sell in a drawer somewhere. Oh, the freedom that brought to my work! If something didn't work out, I'd simply throw it away and start over. I was having fun again, and it showed. That was the beginning of the many images that are now in this book.

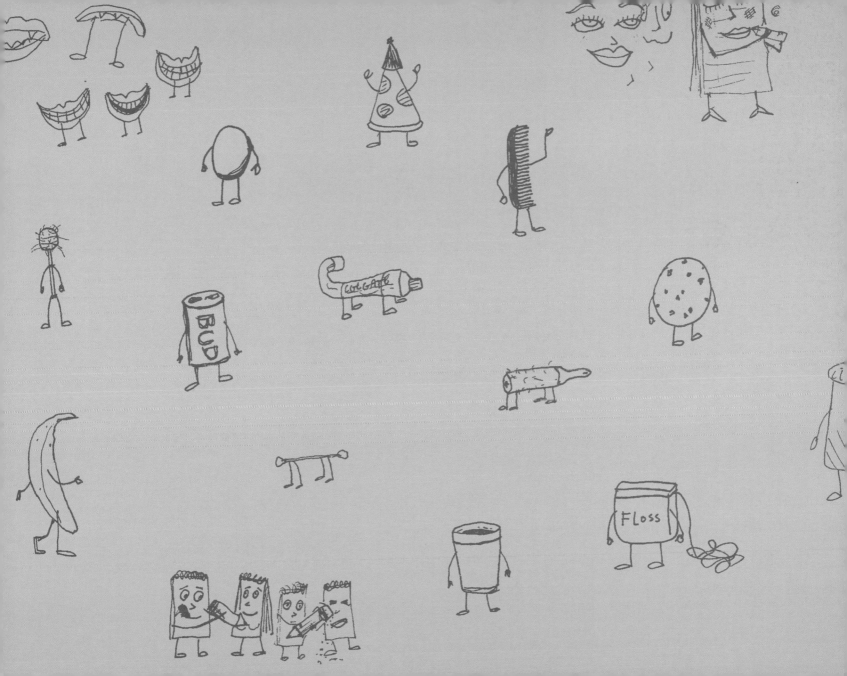

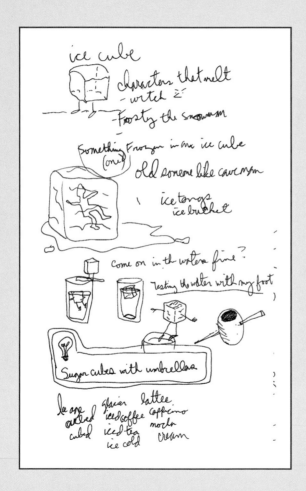

Ice Cube Dreams

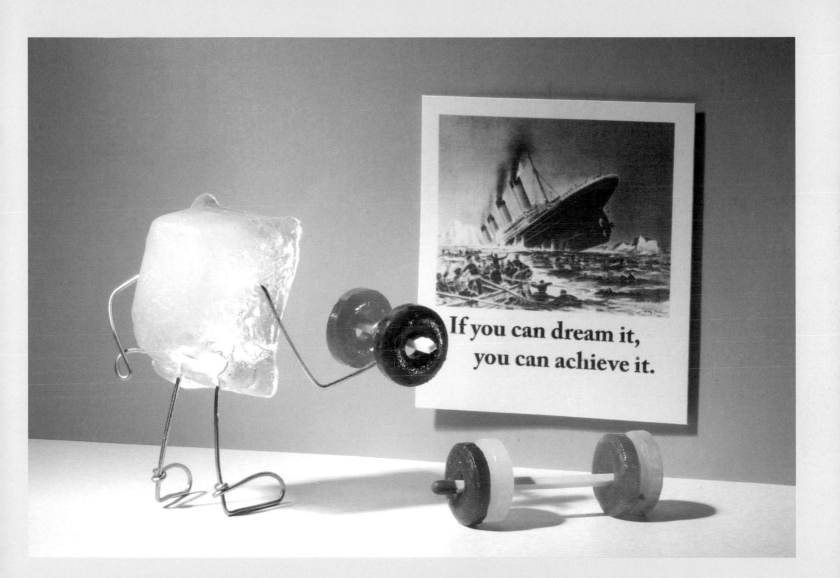

If you can dream it,
you can achieve it.

Kiwi Getting Ready
for the Beach

There was a time not so long ago when body hair on men wasn't a big deal. In fact, men were proud of it. Now, hairy men like me are out of fashion. Life's rough.

—T.B.

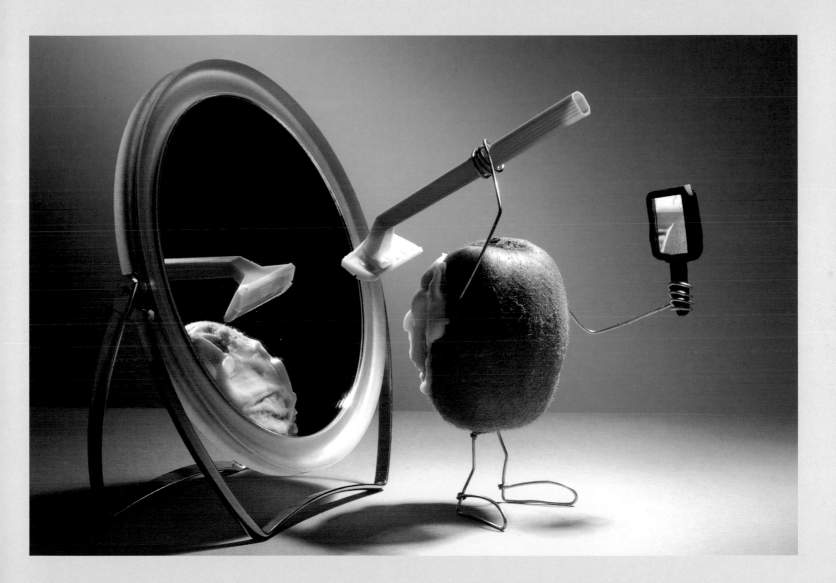

High Maintenance

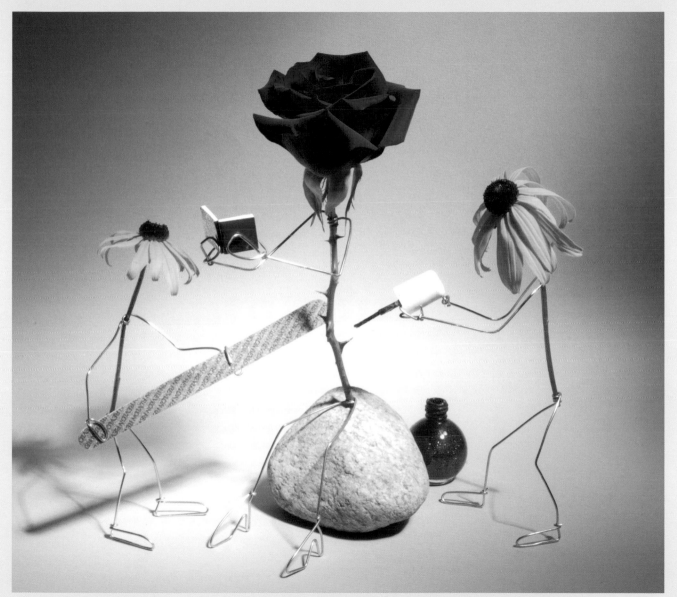

Being Truthful

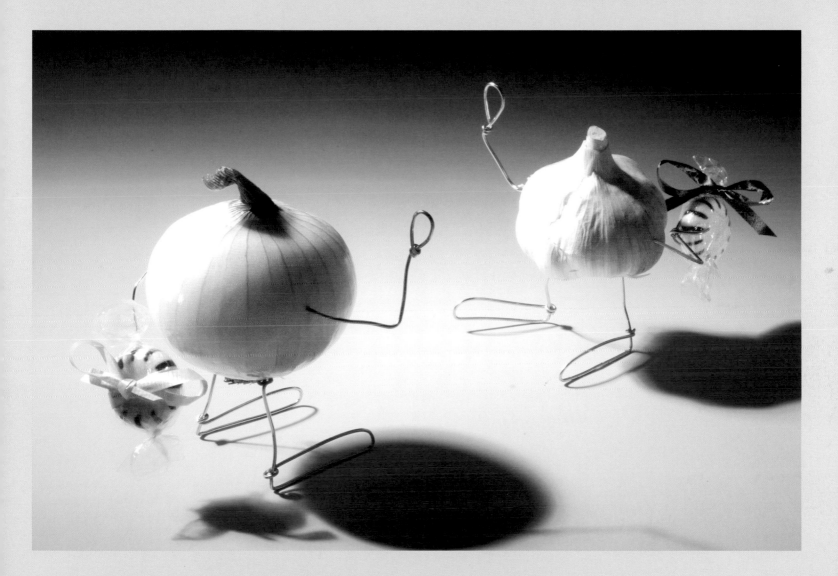

The Royal Chamber

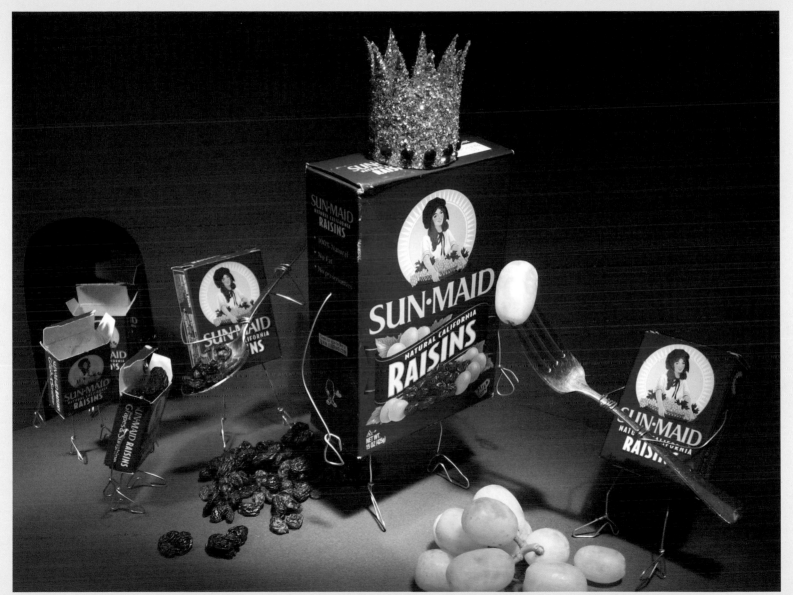

Fiery Rhetoric

Tony Robbins meets his match.

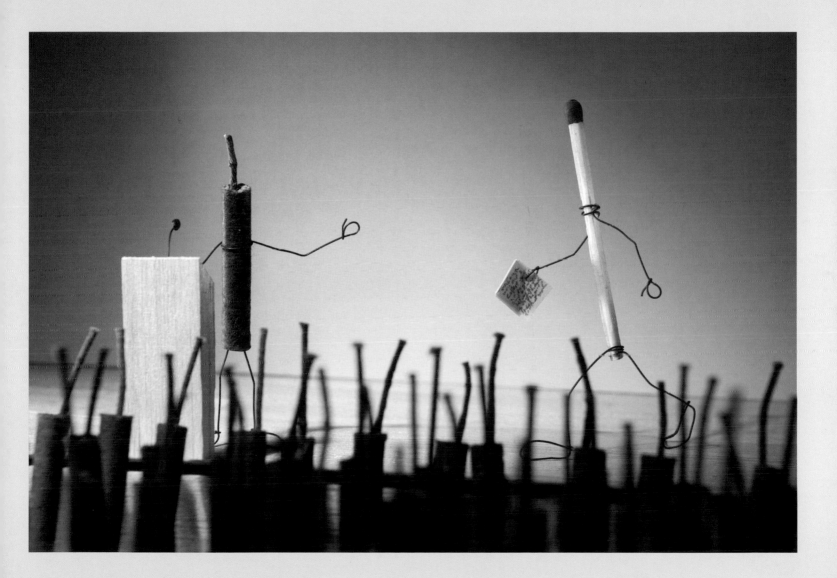

Style Points

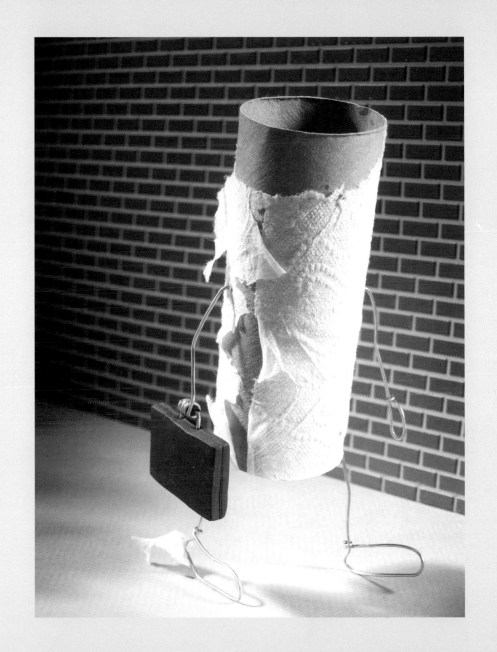

Bad Day at Work

Halloween Candy

I asked my blog readers for an object to use in an image, and the popular choice was candy corn. I learned that the orange part of the candy is easier to poke wires through than the rest. (That's the kind of knowledge I gain from this kind of work.) Luckily, it was near Halloween when I was working on this one. I walked past a bunch of pumpkins for sale, and many of them had big twisted stems, and the shapes of the stems reminded me of really old trees. I picked one out and used it as the setting for my shot. It seemed like a place for a couple of young lovers to share some time together, unaware of the danger that lurks nearby.

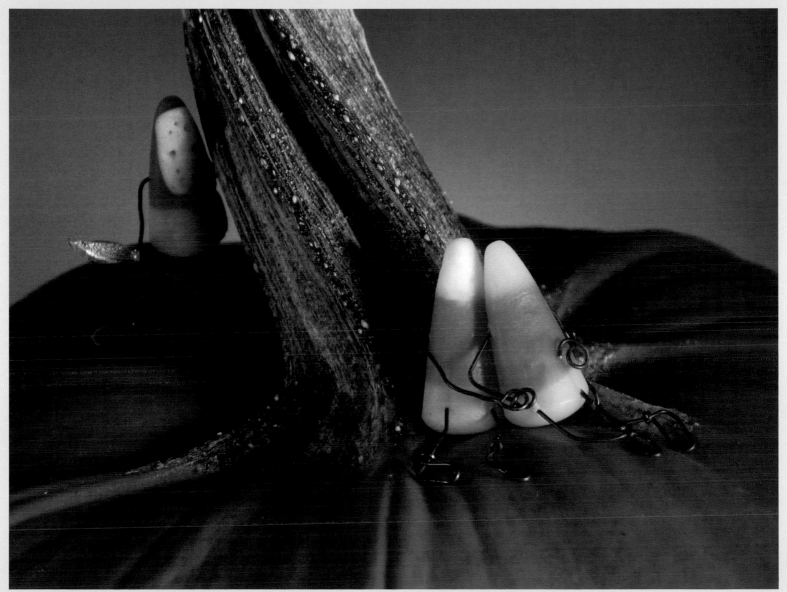

Breakfast is Ready

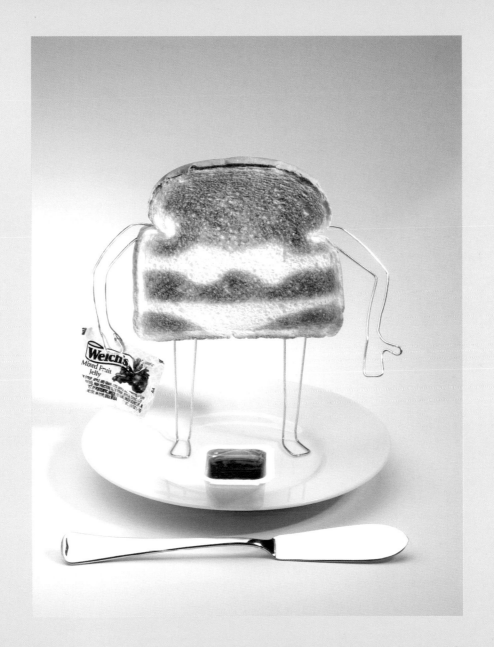

Ping Pong

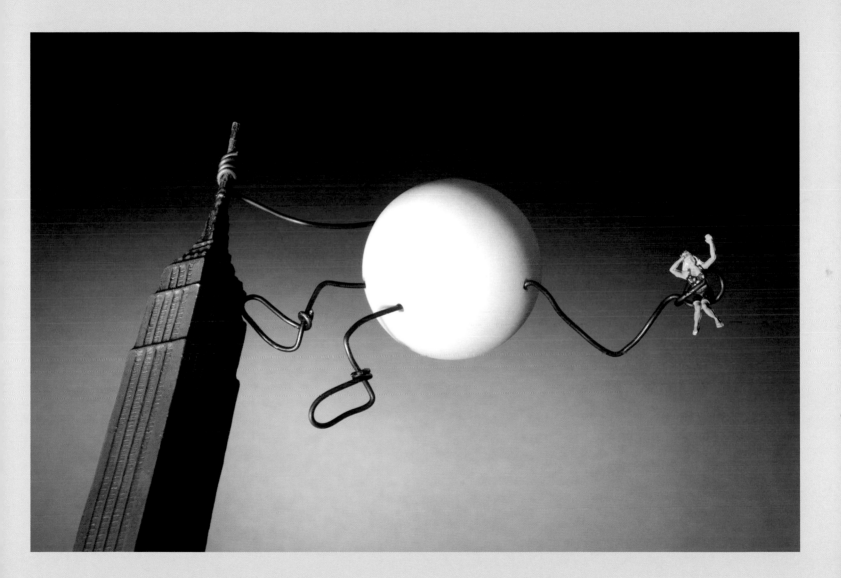

Ending a Dysfunctional Relationship

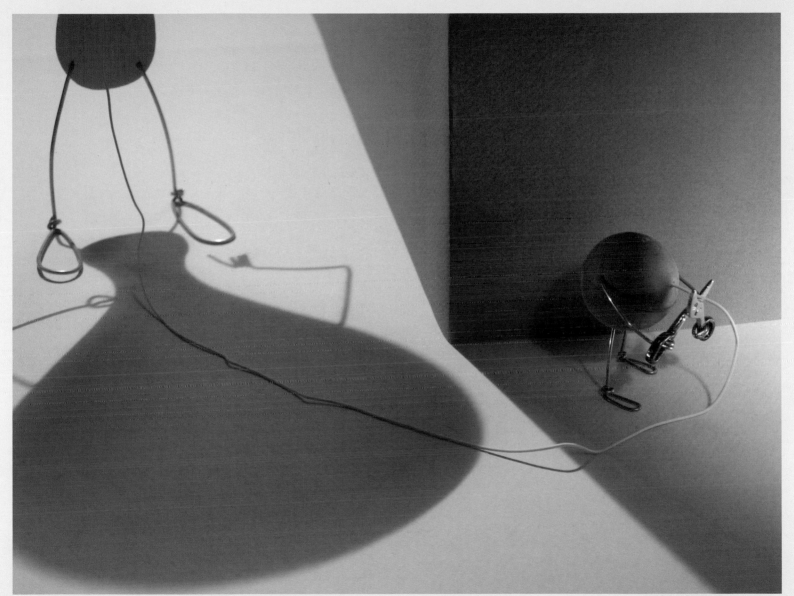

35

Primitive Citrus Were Very Clever Hunters

I had seen an illustration of some primitive people who were able to sneak up on a herd of caribou by covering themselves in caribou skins and horns. I found it hard to believe that kind of deception would work. It just seemed like such a silly situation that I had to do an image about it.

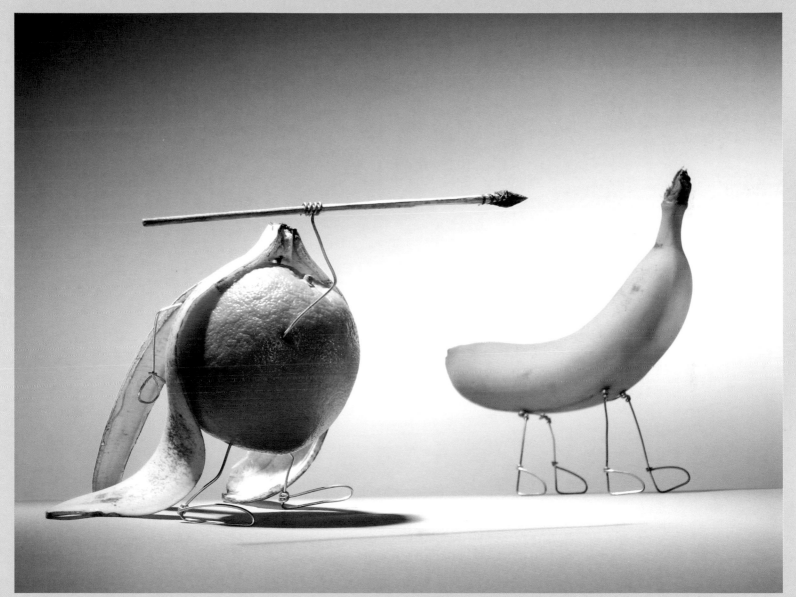

Basil Leaves . . .

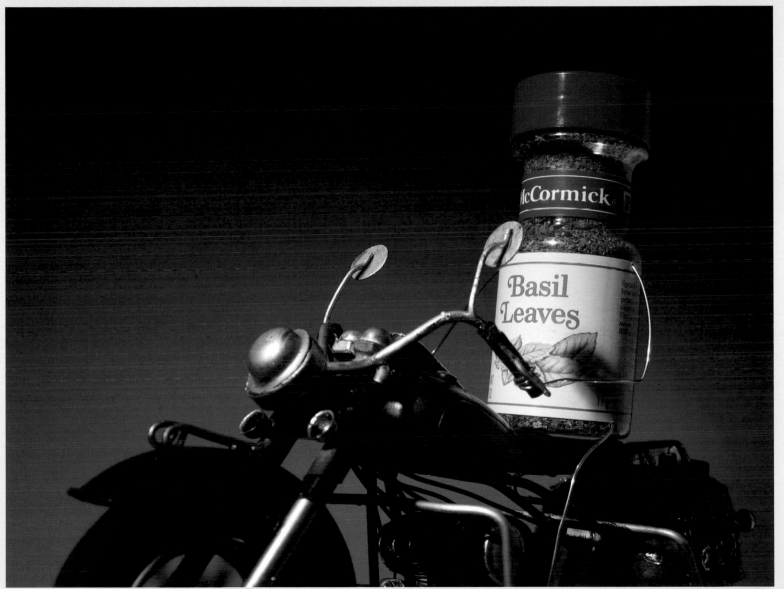

…and Rosemary is Crushed

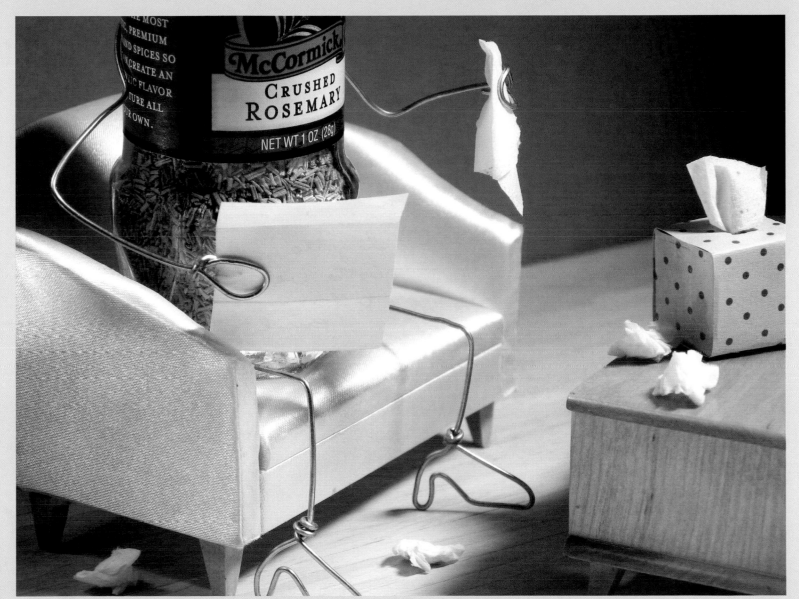

Italian Food Is
Serious Business

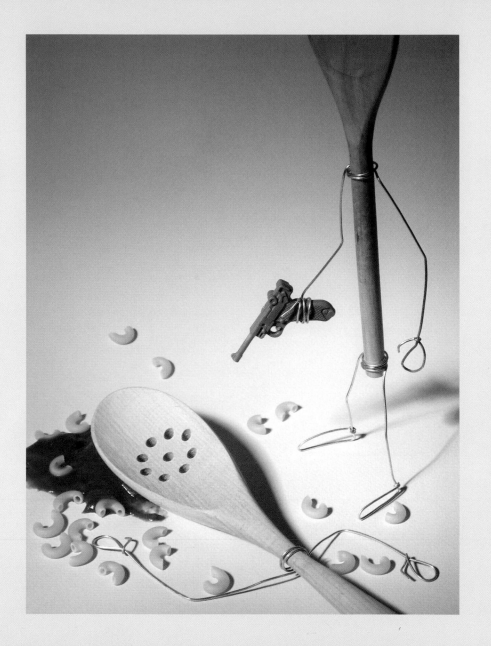

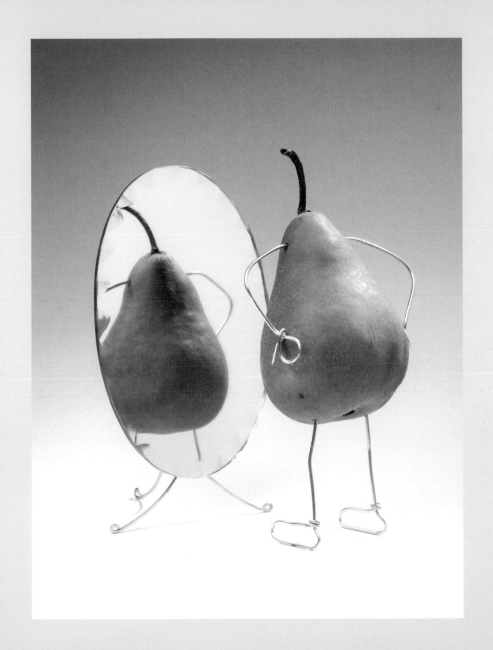

Dis-Pear

Sew Much Drama

I was inspired by the scene in the old movie *Jason and the Argonauts* where Jason and his fellow travelers fight the giant crab.

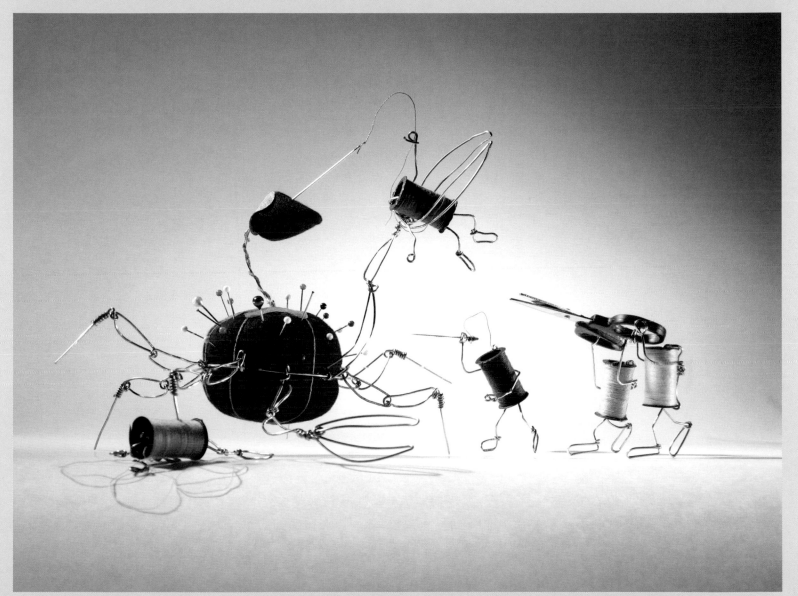

Mail-Order Bride

～

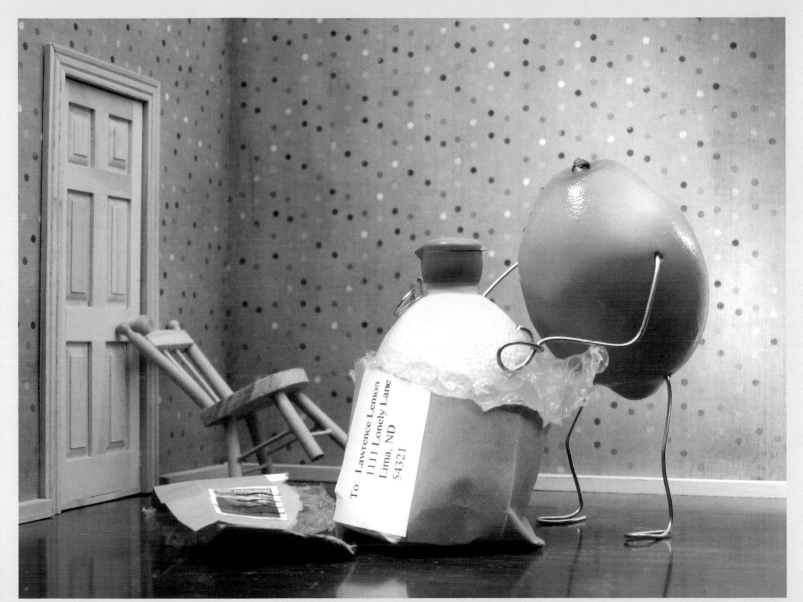

To: Lawrence Lemon
1111 Lonely Lane
Lima, ND
54321

47

It's a Dirty Job, but . . .

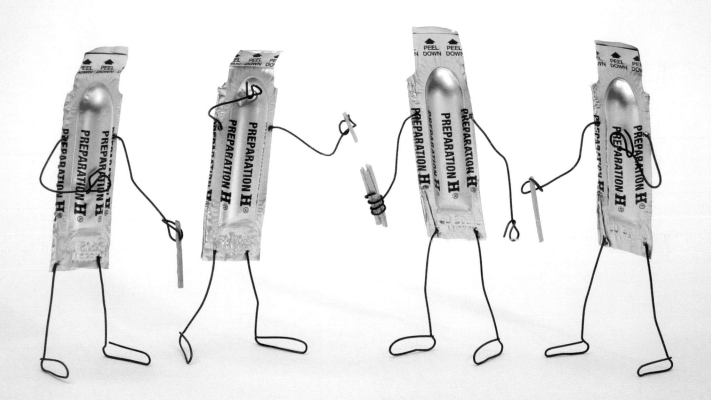

*Aaaar*shmallows

I've told people before that if you can put a peg leg and a patch on a little marshmallow character, you'll have a winner. I bought this mug especially for this image, and it's still my wife's favorite soup mug.

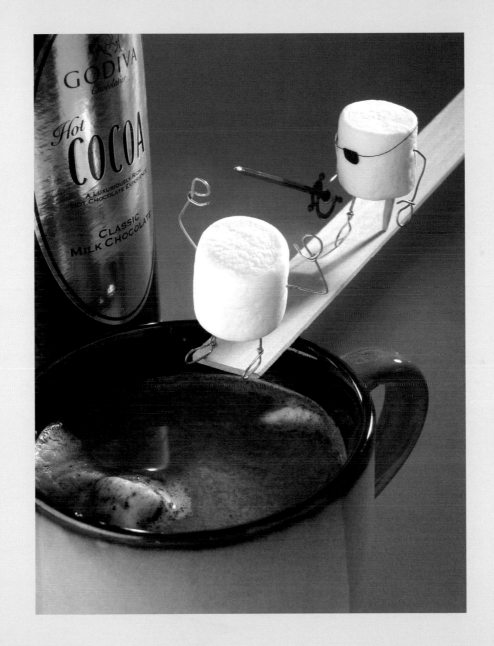

Star of the Show

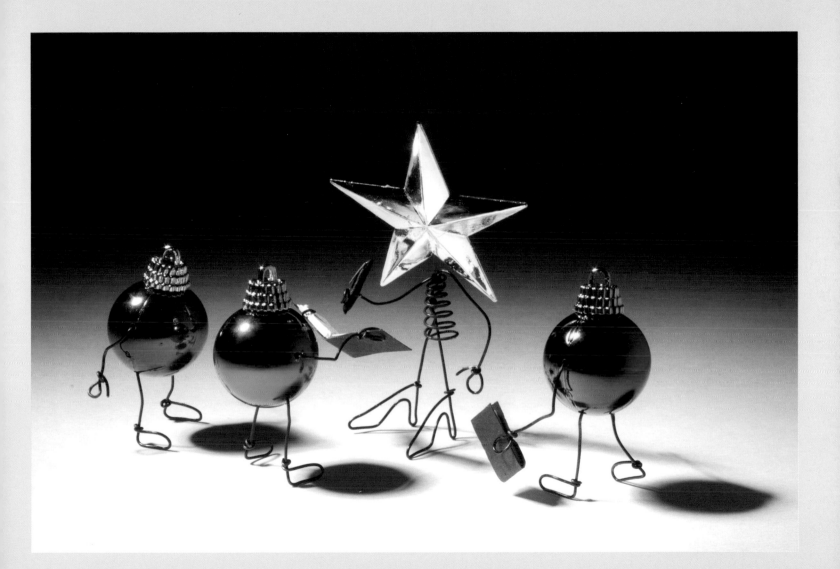

Busy, Busy, Busy

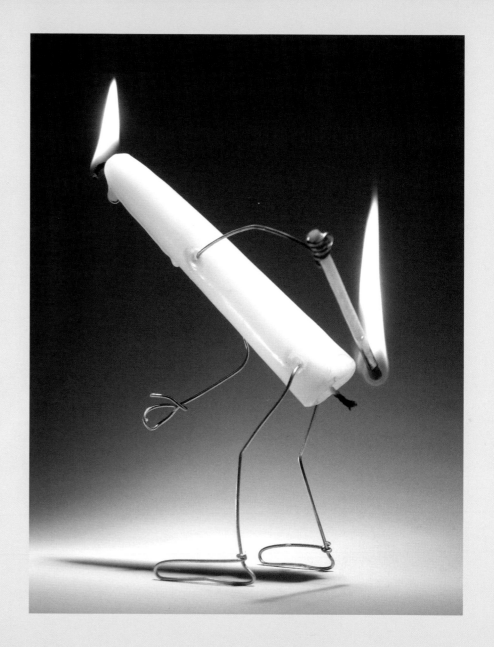

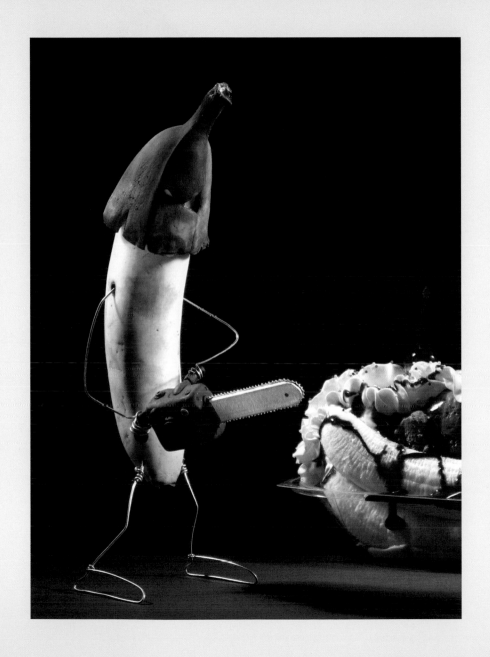

Banana Chainsaw
Massacre

Chained
to His Desk

~

They wanted him to work there until he was

bled dry, but he had other ideas . . .

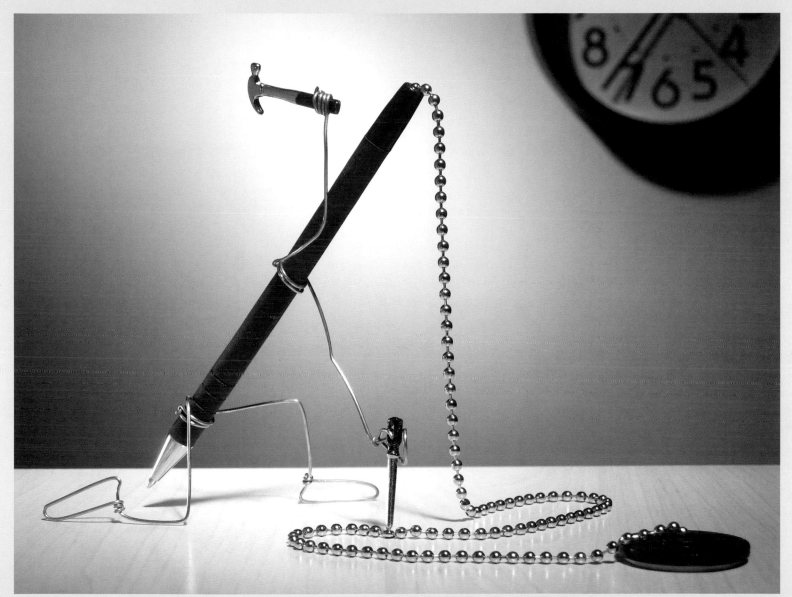

It's a Dangerous Lifestyle

Drummers are usually the really wild ones who get themselves into trouble. My favorite band is The Who, and this one is in honor of their drummer, Keith Moon, who died much too young, but was famous for having a good time. The drumsticks were originally toothpicks, and I'm happy with how they came out. The guitar belonged to Barbie, but she really never learned to play. (She liked the *thought* of being a guitar player, but liked riding around in her convertible more than finding the time for practice.)

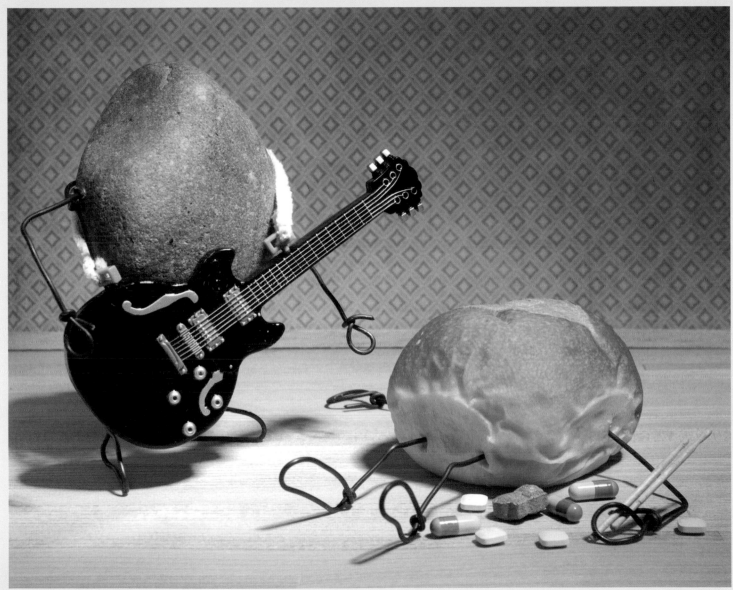

Perspective Drawing

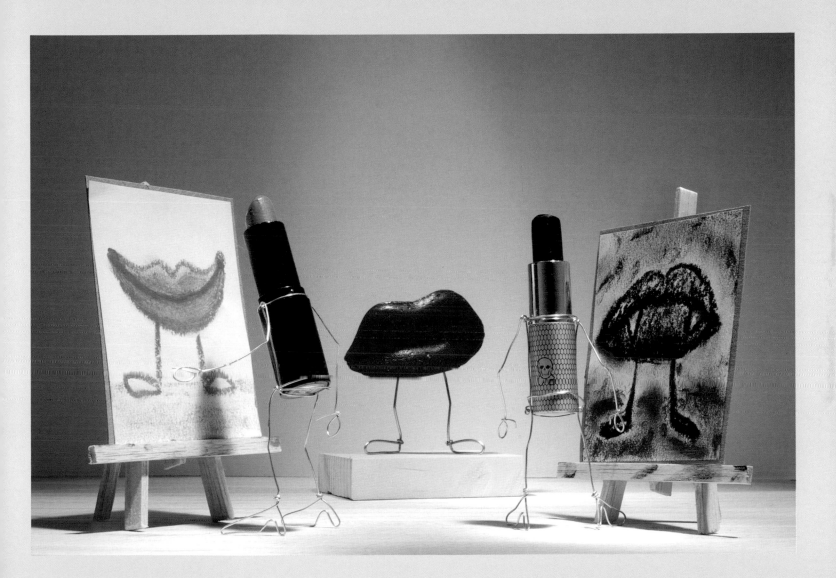

Earl Grey's Favorite
Way to Relax

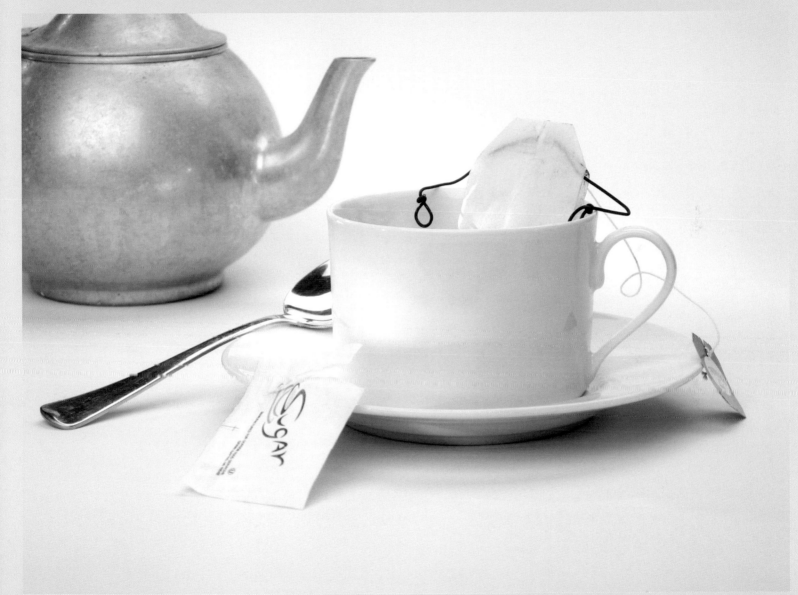

Relishing Life and Death

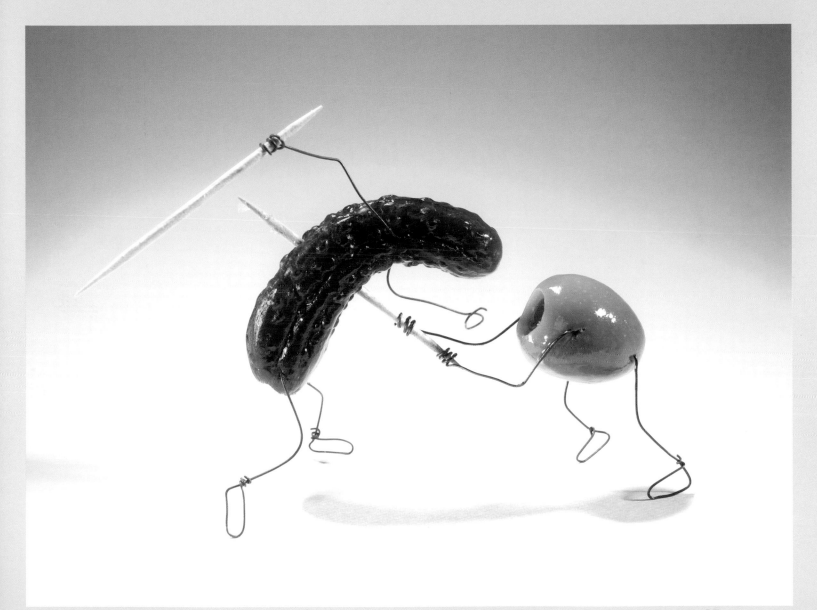

Lactose Intolerant, or Milk is a Cereal Killer

Is there any texture less appetizing than soggy cornflakes? I find it too stressful eating cornflakes for just this reason—it's a race against time the minute milk is poured over them. "No time for pleasant morning conversation, thanks. I'm busy trying to eat my breakfast before it drowns!" (I also remember the stress of eating my toasted oats with tiny marshmallows cereal when I was little. Nowadays they've added more of the marshmallows per box, but when I was small, a successful breakfast depended on a lot of rationing of the marshmallows, so you still had some for your last spoonful!)

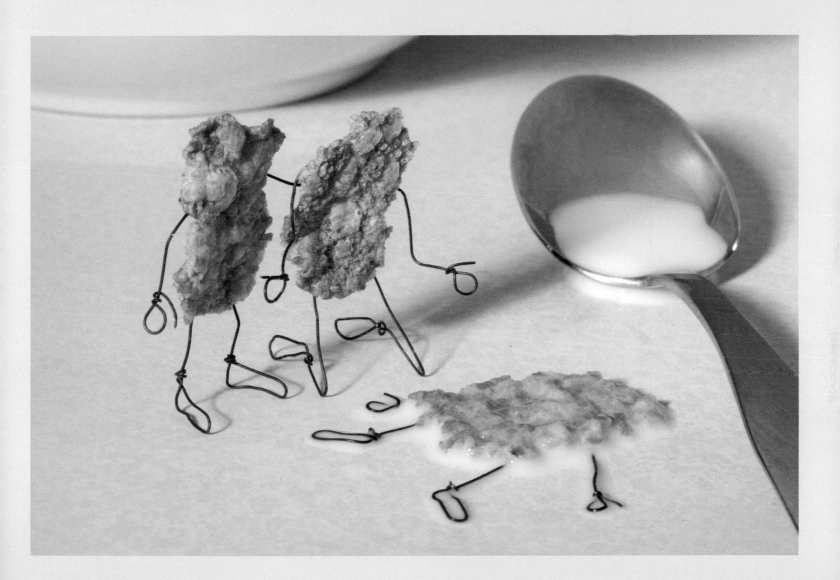

Caught Orange-Handed

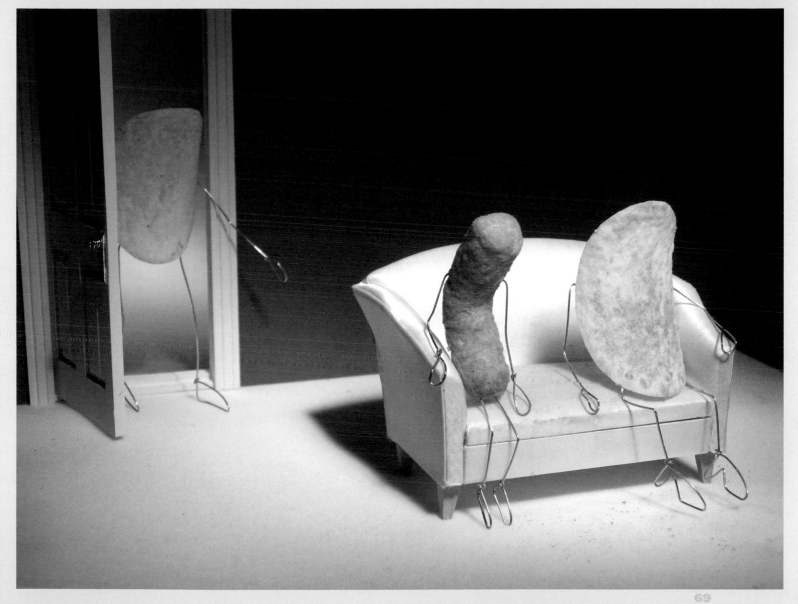

Gulliver's Travels

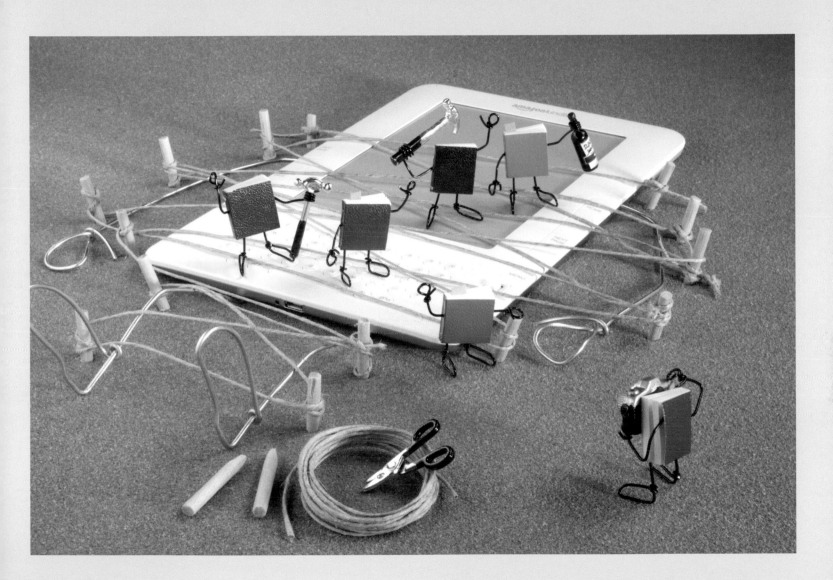

Office Supplies in the Jungles of South America

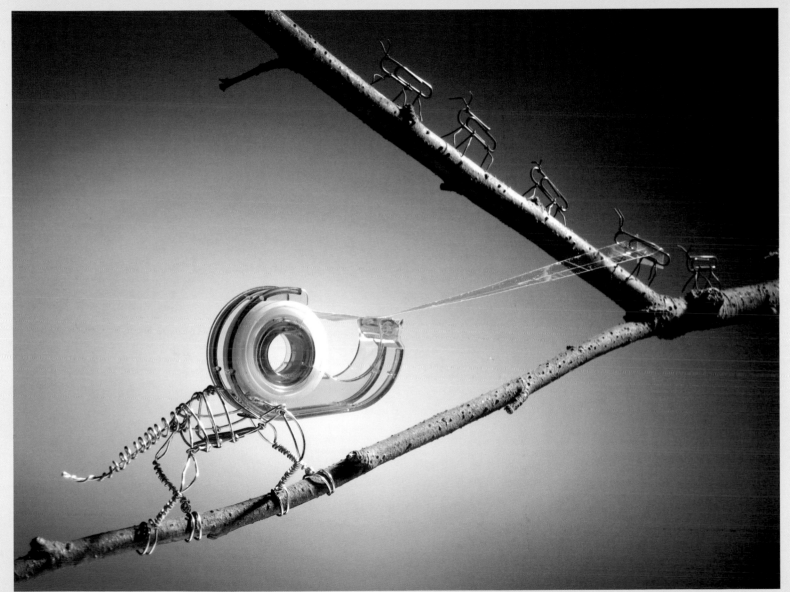

Vincent

My wife and I are both big art lovers, and her favorite painter is Van Gogh. This in turn has lead to her favorite flower being the sunflower, which we grow in our backyard each summer. That's where this fella came from. People sometimes ask where I get my ideas, and like any person, ideas can come from anywhere. This particular image idea can almost be explained by listing what a person immediately thinks of when they hear the name "Van Gogh":

- ✔ Painter
- ✔ Sunflowers
- ✔ He cut his ear off.

So we have a sunflower represent Vincent, posed as a painter, and I cut some petals off to represent his missing ear—*voila!*

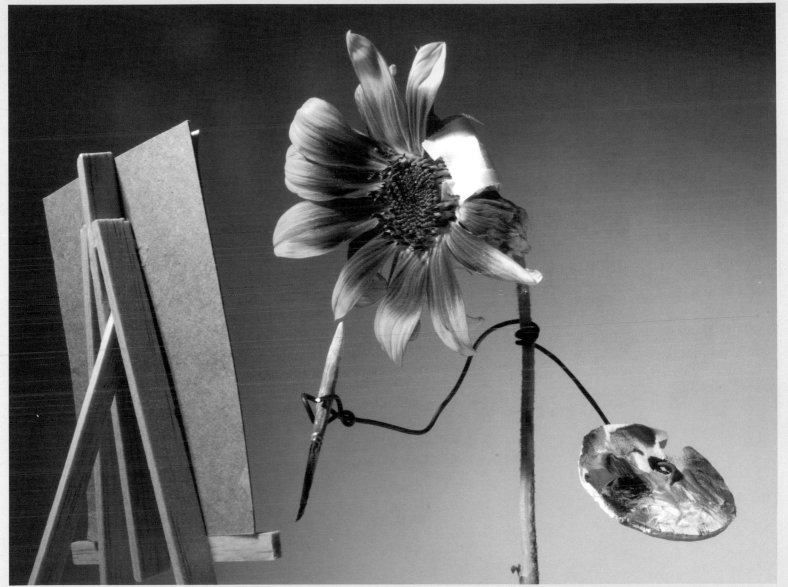

(S)Carrie Meatball

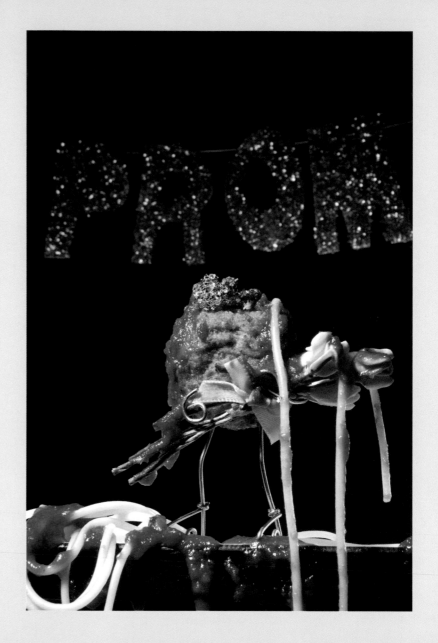

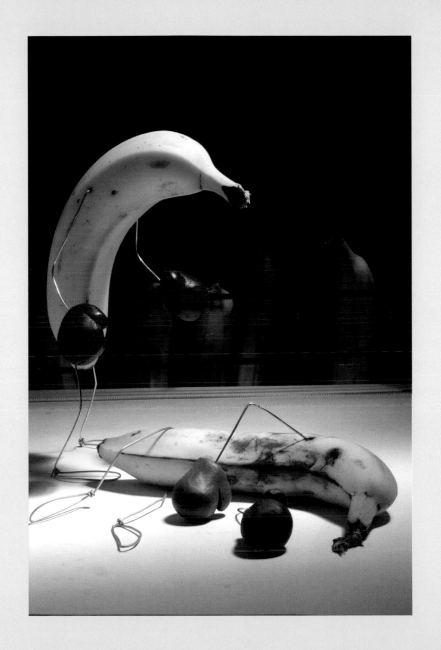

Badly Bruised

CSI Rookie

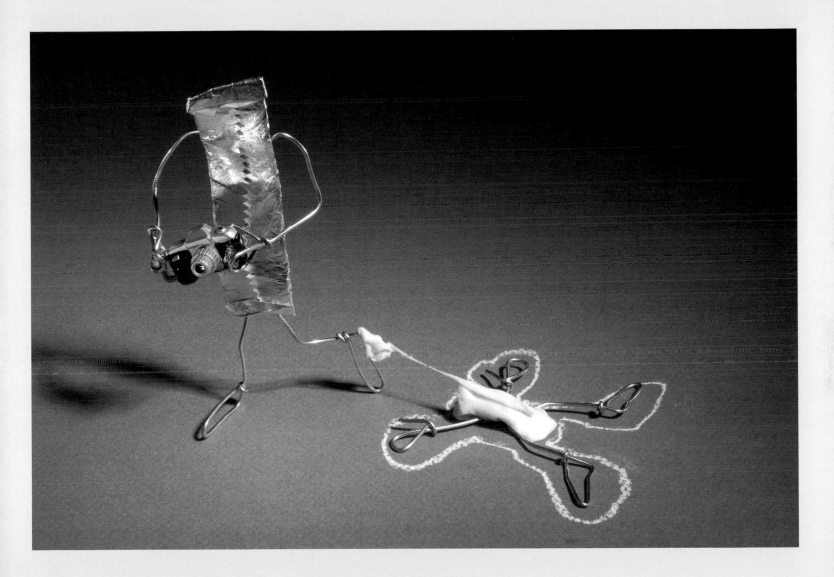

Problem Child

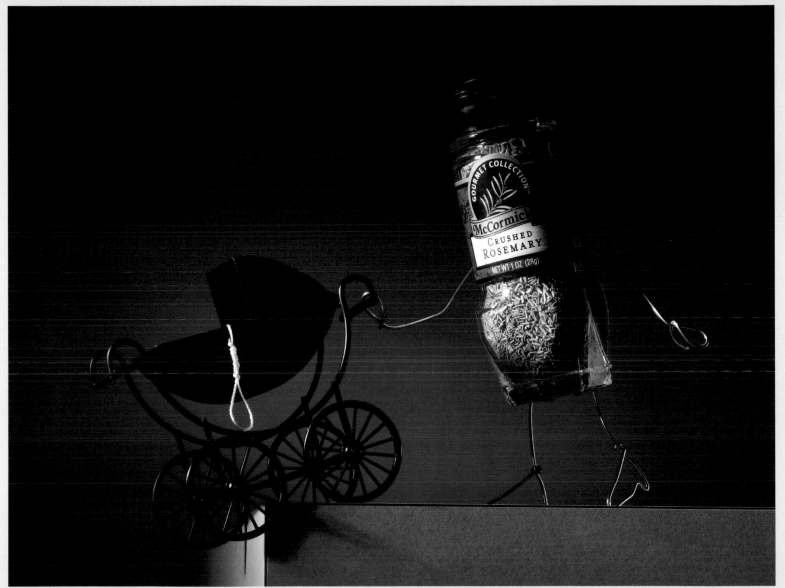

Sometimes Being Special
Isn't So Special

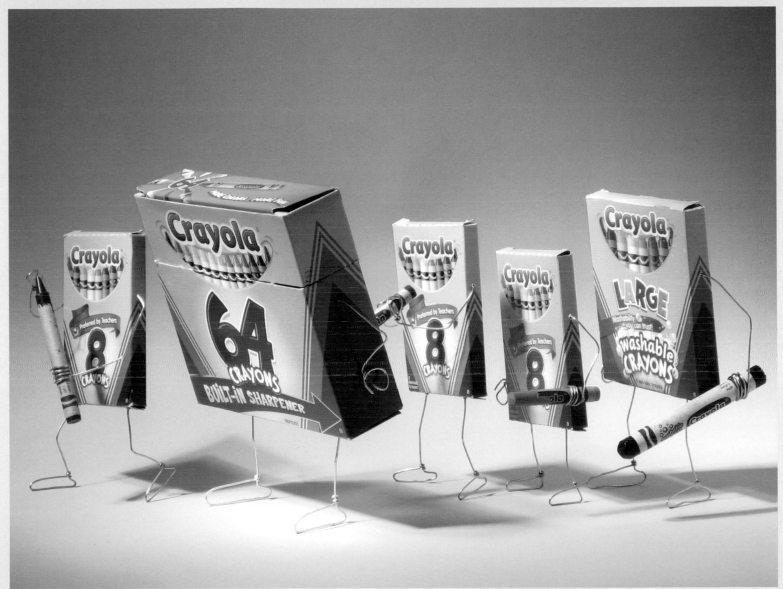

83

Kiss my ash . . . er,
I mean butt!

To make this image, for the first time in my life, I held a cigarette to my lips to get it started. At age 42, I found it as bad tasting as I imagined, and it stank up my little studio quite a bit as it burned! I borrowed the ash tray from the outdoor seating area of a famous coffee chain. (I should probably return it.)

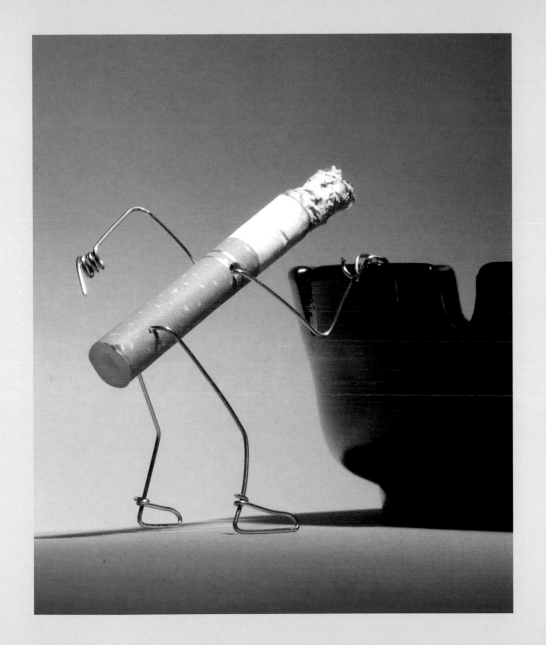

Dancing Queens

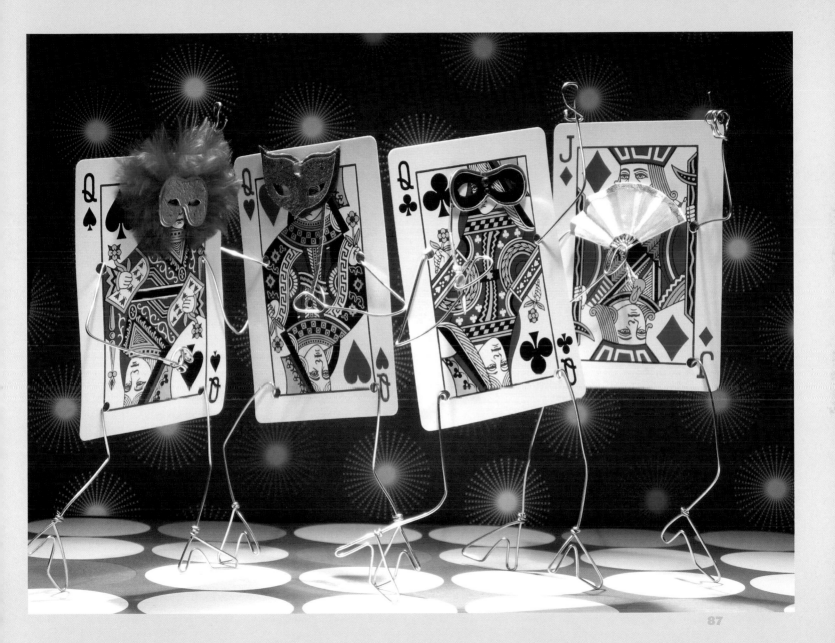

Cleaning Up
the Scene of a Crime

Belated

I had my little photo set all ready before I went out and bought the roasted chicken from a supermarket deli. I had the little egg character standing there with the card and everything, and had the lighting roughed in (set up). So I brought the chicken home, put it in place, and after about twenty minutes I had the image. I then brought the still-warm chicken into our dining room where my wife and daughter were waiting, and we had dinner.

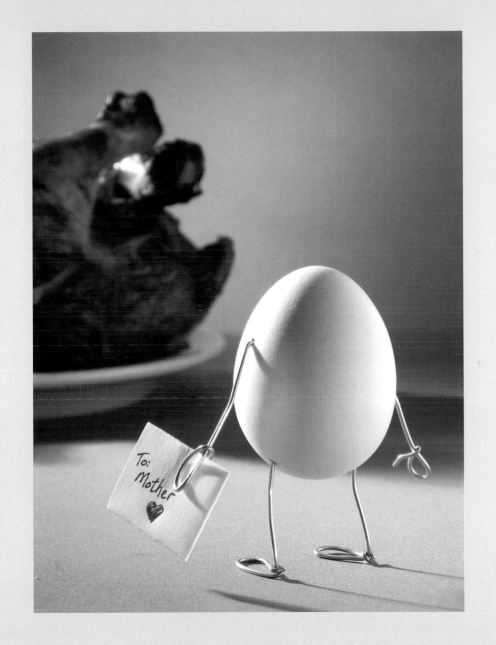

A Tough Interviewing Process

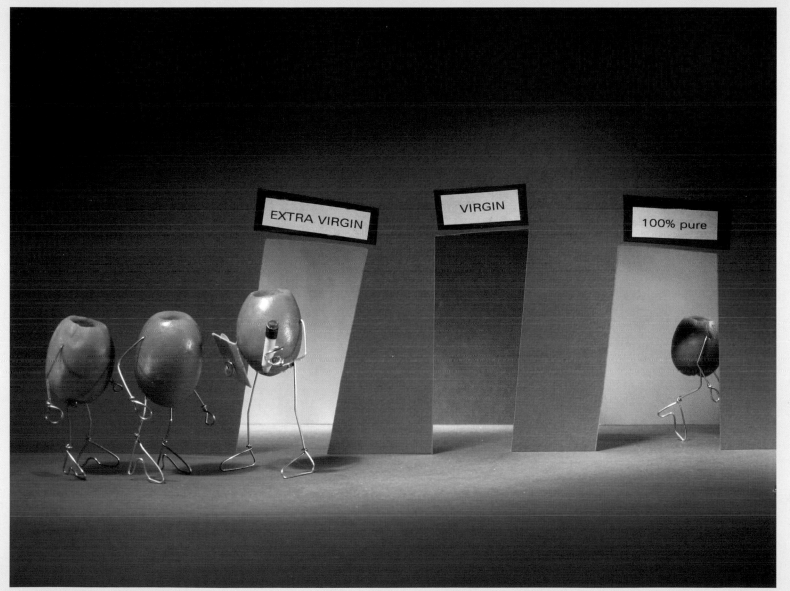

This Chap Sticks the Landing

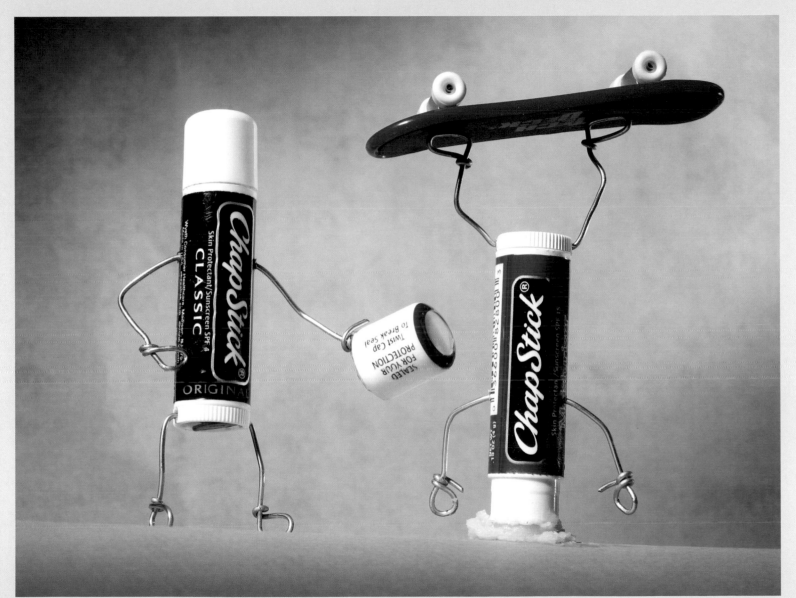

Thyme's Almost Up

Wouldn't it be terrible if we had our expiration dates stamped on our bodies somewhere? (Although a "Best If Used By" date might come in handy sometimes!)

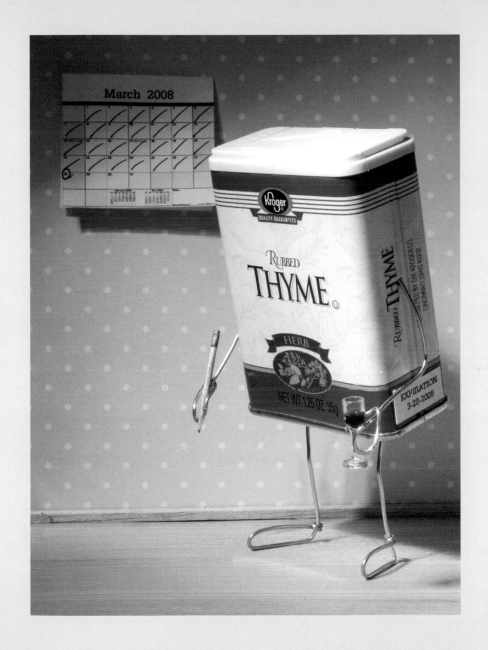

Only Slightly

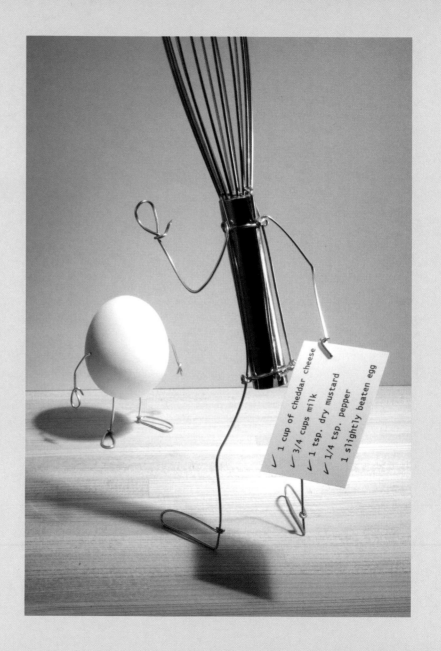

The recipe card reads:
- 1 cup of cheddar cheese
- 3/4 cups milk
- 1 tsp. dry mustard
- 1/4 tsp. pepper
- 1 slightly beaten egg

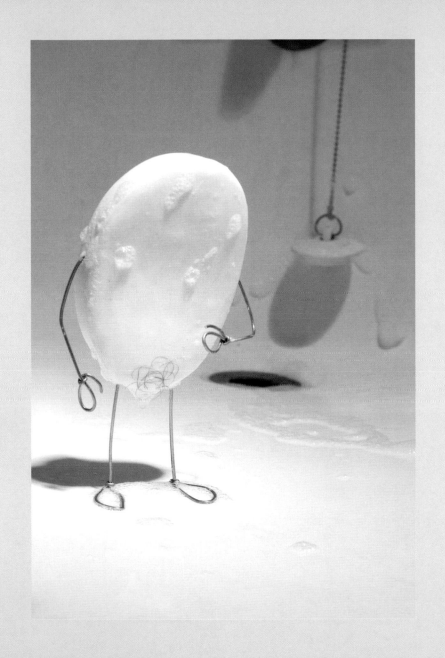

Curly Hair

Rejection

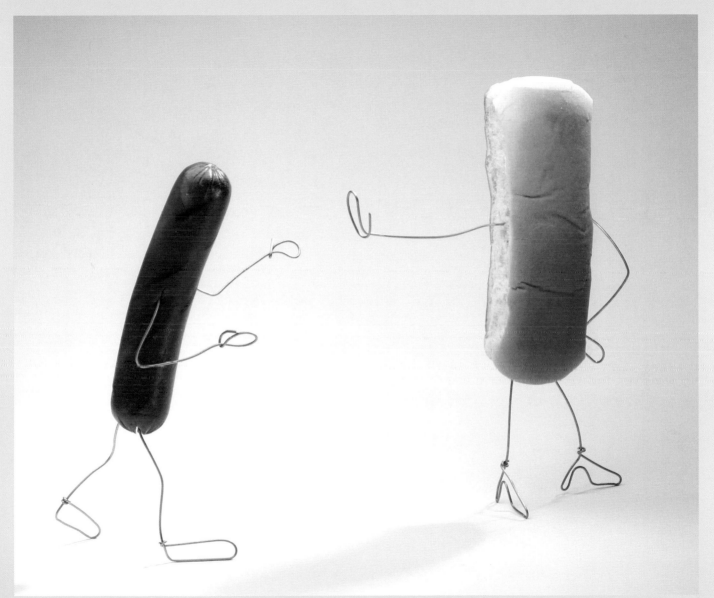

101

Fighting Temptation

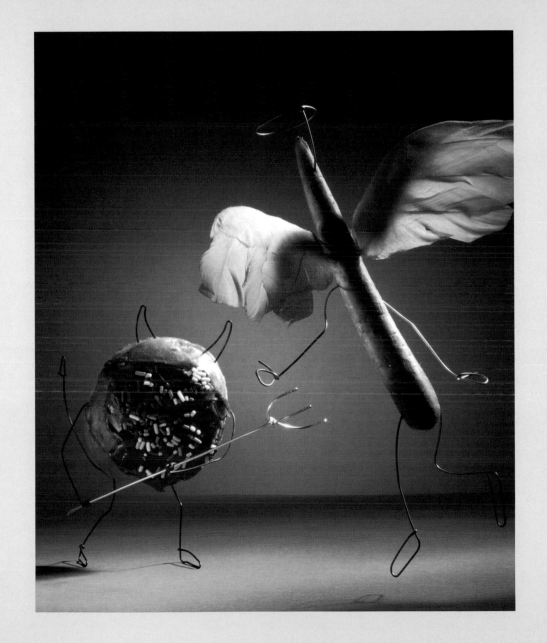

My Ego Is Getting Out of Control

This is a tribute to Michelangelo, of course. Since my wife and I are such art lovers, ideas having to do with art and artists are always floating around our house. I've made a Warhol character out of a tomato soup can wearing a white wig, a different one of Van Gogh as an ear with arms and legs, holding a paintbrush, and many others that I haven't followed through with yet. I've been to Rome twice, and on both occasions the Sistine Chapel was closed. I'll get there someday, maybe. (I do kind of imagine God saying to Adam "pull my finger" on Michelangelo's version.)

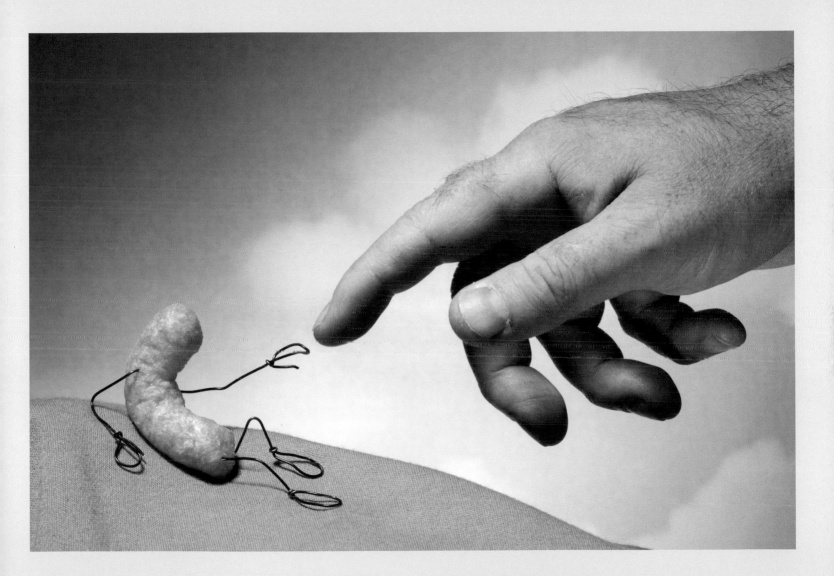

The Day
Two Bullies Met

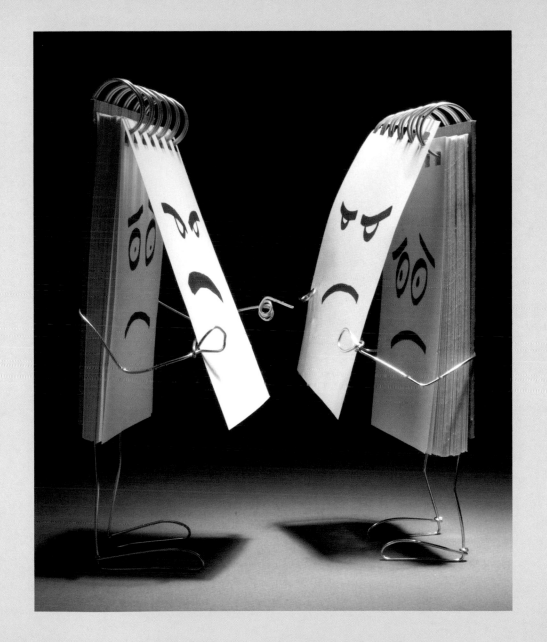

Being a Straw in Love Sucks

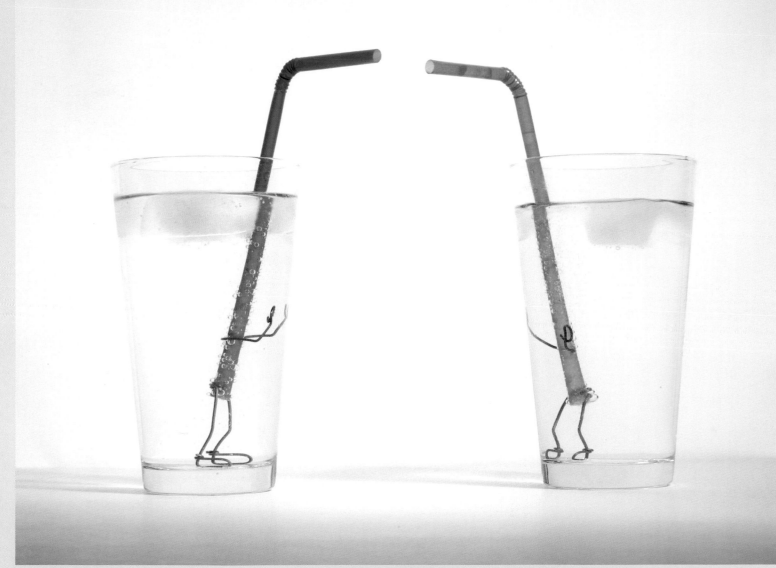

Peanut Mourning

This was one of my first narrative images—a small story being told by my scene. To this day, it's many peoples' favorite, including my mother and mother-in-law. (Kind of depressing in a way, really. Like I peaked too soon!) Whenever I start an image like this, I bring a bunch of peanuts, cornflakes, candy corn, or whatever, home and dump them on our dining room table. I begin searching for the characters. For the child character here, I just had to find a small peanut, obviously. For the father, I just had to find a normal, generic looking peanut. The mother though—I had to find a somewhat curvy one, a shell with a bit of a woman's shape, and I think I found her. Casting director for peanuts, that's me.

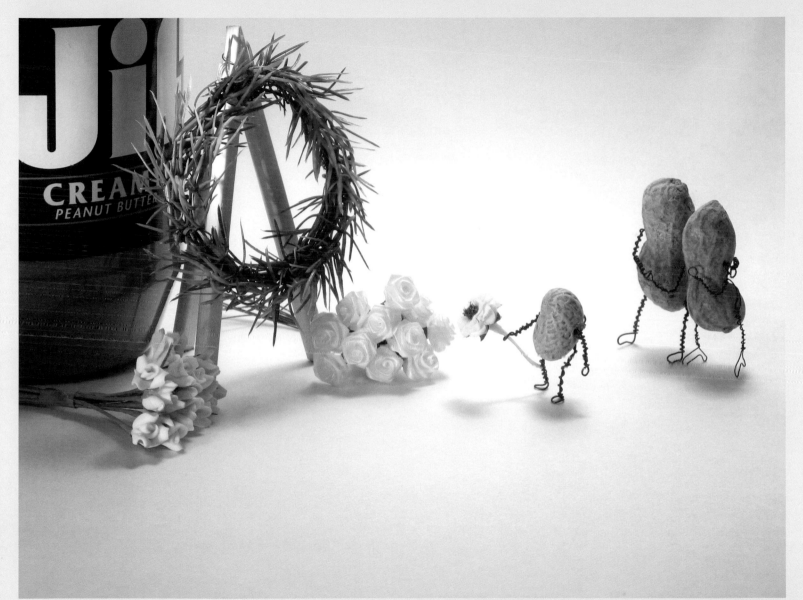

The Attraction to Bad Boys

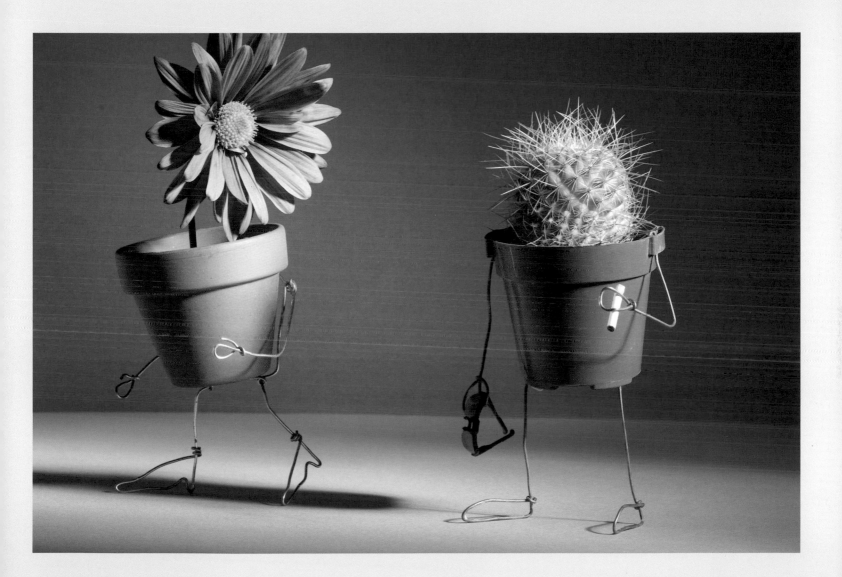

We All Have Our Ups and Downs

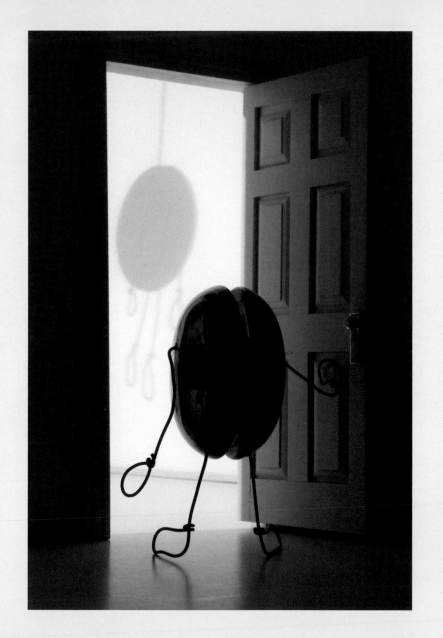

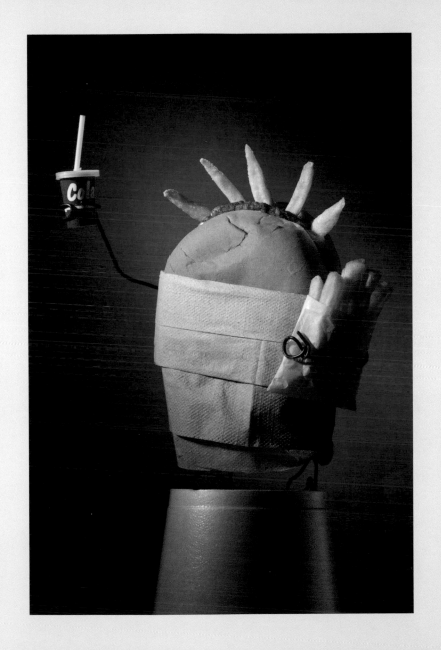

The American Way

Can You Count on Your Friends?

Can you? It's impossible to tell until times get tough, right? For several years I worked as a baker, and I made this shot at that time. These rolls were my daughter's favorite, but I managed to hide two for this image.

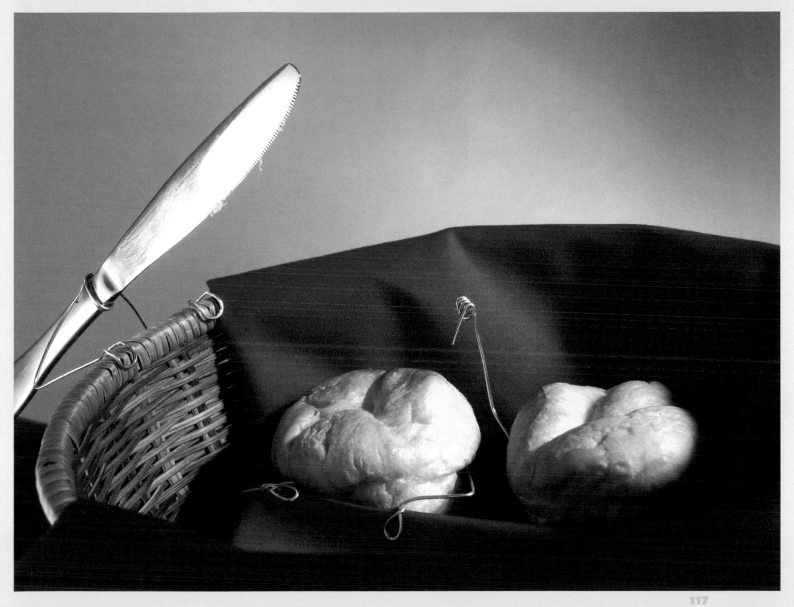

So Help Me God

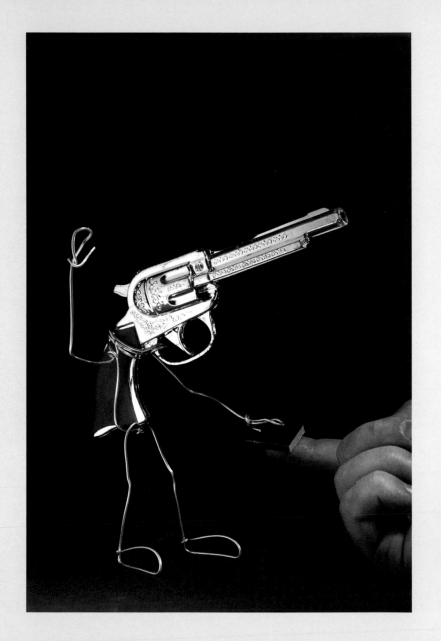

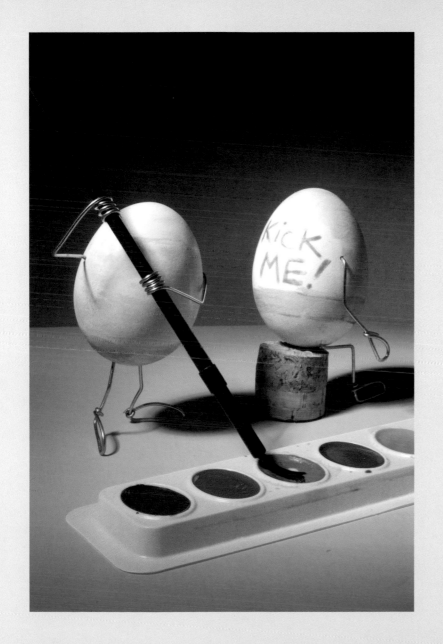

Practical Yolker

A Father's
Point of View

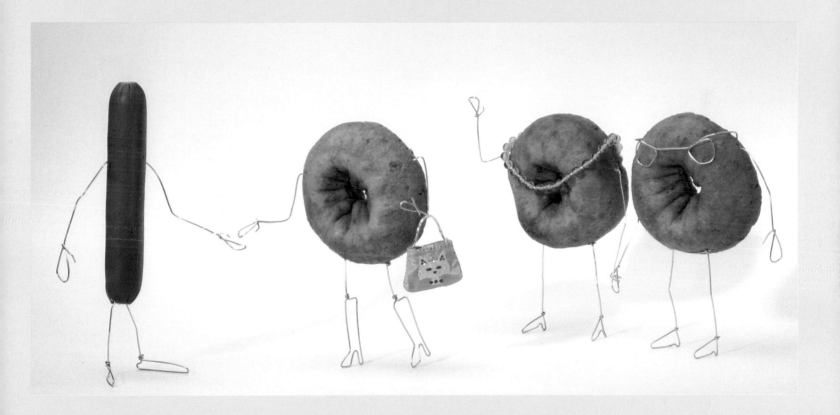

He Loves Christmas

Of *course* he loves it—he spends the rest of the year boxed up in the attic!

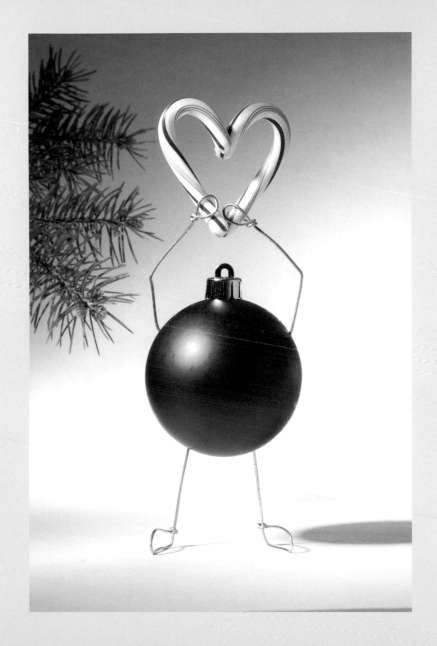

Where There's Pork, There's Beans

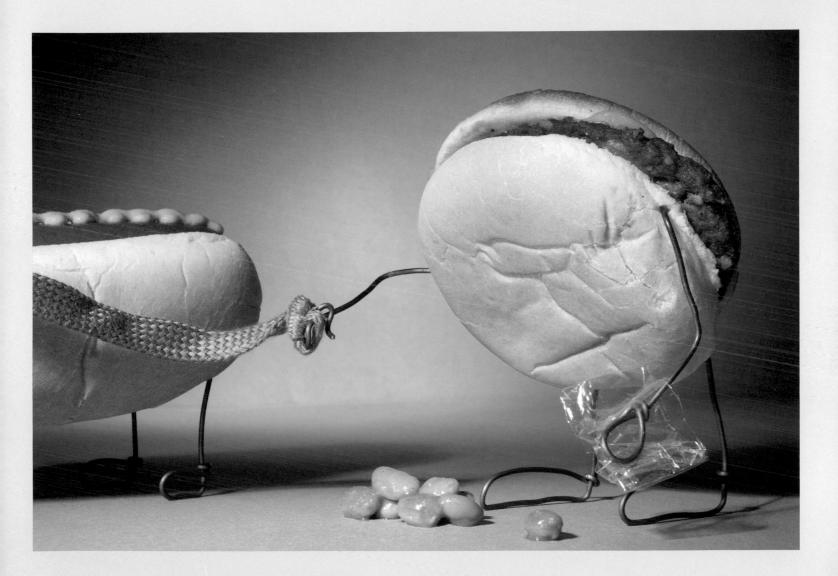

Waiting for the Train

He always seemed so nice in the chat room. Earlier in the evening, she even agreed to go "dutch" and pay for her own movie ticket and popcorn. She was really upset about that.

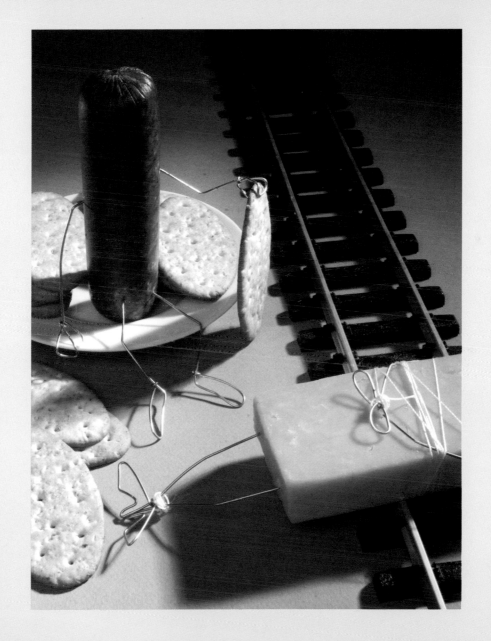

A Slight Chemical Imbalance

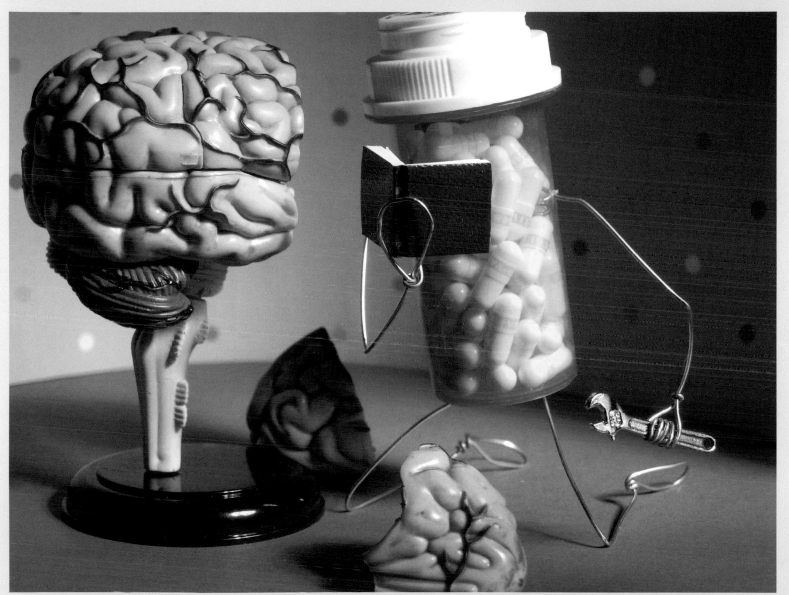

Friday Night Fights

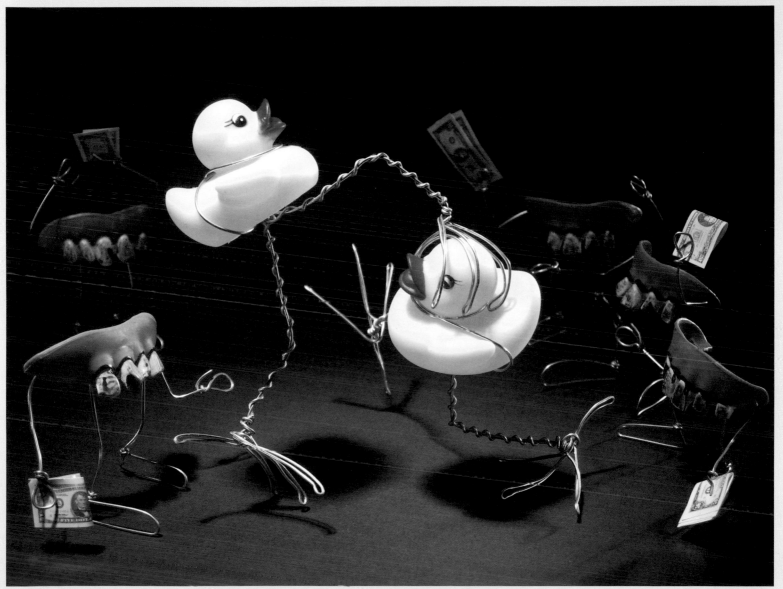

At the Party

Sometimes my work can be very autobiographical.

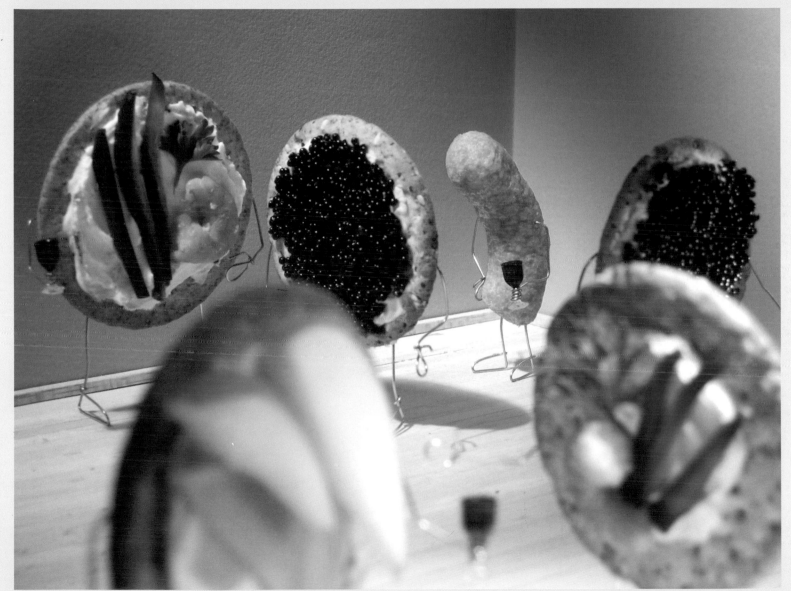

A CORK PERSON HOW-TO

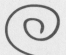

I am often asked how I bend wire to make things. One of the first pieces that I created from objects is a cork person. Though it's simple enough, it can be customized into countless variations, and given as a gift, or can sit at your desk to guard your paper-clips.

(Here's some honesty that you'll rarely read in a "How-to": your first attempt will more than likely come out hideous. Your second try, however, will be much better, so don't give up!)

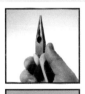

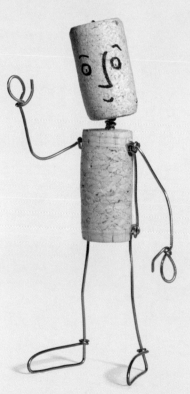

Materials:

✔ I use a standard set of long-nosed pliers for most of my bending and cutting.

✔ I also use a set of mini- round-nose pliers for making small loops and smooth bends, but they are optional, and I've done without them on many projects.

✔ For this project, you'll need a roll of galvanized 18-gauge steel wire. It's inexpensive and available at your local hardware store.

✔ A pair of safety goggles are a good way to protect your eyes from the end of a long piece of wire.

✔ Lastly, you'll need two wine corks. Synthetic or real cork, it doesn't matter.

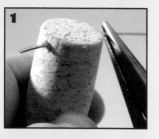

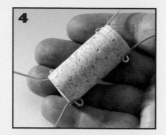

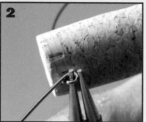

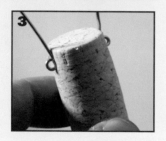

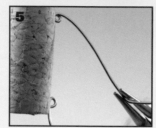

1. Holding the end of the wire with your long-nosed pliers, gently but firmly push it through one end of the cork with a little bit of a twisting motion. The wiggle of the wire back and forth helps the end of the wire drill through the cork. Don't try to push more than a quarter-inch through at a time or the wire will bend before it even gets into the cork. Keep your fingers on the wire less than a half inch from the end of the cork to keep the wire stable. After it emerges from the other side, pull a good eight or nine inches through the cork, and leave the same length on the other end. Then cut the wire from the wire roll.

2. Using the round-nose pliers, grab the wire about half an inch from the cork and bend the wire back toward the cork. Continue bending until you have a small loop that is fairly tight up against the end of the cork.

3. Do the same for the other side.

4. Repeat Steps 1 through 3 at the other end of the cork.

5. Working with the pair of wires you want to be the arms, make a slight bend where the wrist should be.

6. Holding the pliers firmly, bend the loose end of the wire around so that you've formed an oval loop that will be the hand. It should be around a half inch at its longest diameter.

7. Now tightly wrap the remaining free end of the wire around the arm at the wrist.

8. Cut the extra wire off, leaving just a bit to be a thumb. Repeat these steps with the opposite arm.

9. The wire coming through the other end of the cork will be the legs. Using the pliers, grab the wire at the point that will be the heel—say a finger's width from the end—and make a sharp 90-degree bend. This will be the bottom of the foot

10. Remember that the larger the feet are, the easier it will be to balance your cork person. Hold the wire at end of the foot (where the toes would be) with the pliers, and use your fingers to bend the wire up and back toward the leg to make the top of the foot.

11. Wrap the wire tightly around the leg at least once to finish the foot at the ankle.

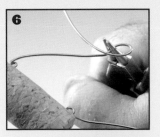

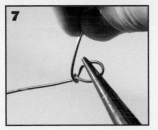

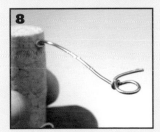

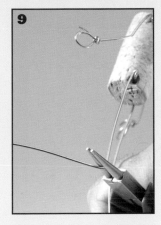

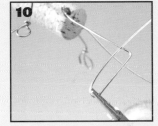

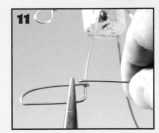

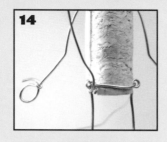

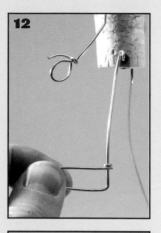

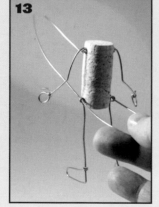

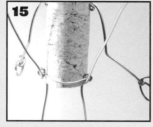

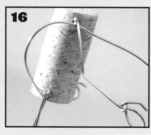

12. Snip the extra wire off as close as you can to the leg. Use your long-nosed pliers to crimp the cut end of the wire tightly against the ankle. You don't want a sharp piece of wire sticking out anywhere. Repeat this process for the other leg, holding the legs near each other to match the lengths as best you can. Now we need to connect the leg wire to the arm wire, to make a sturdy cork person that can assume a variety of poses.

13. Cut a foot long strand of wire from the coil, and bend at it middle to make a narrow U-shape. Then thread the two ends through the little loops where the legs are connected to the cork on either side. This one piece of wire will connect to both arms.

14. Pull the U-shape snug against the back of your character, then tightly down and around the little loop.

15. Do the same for the other side.

16. Now thread the ends of these wires through the loops at the "shoulders."

17. Wrap these wires tightly around their respective loops.

18. Cut off the extra wire and use the pliers to tighten the loops you just made. There will be a wire running up each side of the "body," as tight against the side of the cork as possible. This is all for stability in case your character gets top heavy.

19. The body is now finished.

20. For the head, cut a piece of wire about a foot long, then push and twist one of end length-wise through a second cork. It rarely emerges from the center of the cork's opposite end, but that's O.K. (As you can see from the next picture, the wire emerged at the edge of the other end of my cork!)

21. Pull eight or nine inches of wire through this cork. With the remaining three or four inches of wire, sharply bend it close to what will be the top of the head, and down the side of the cork.

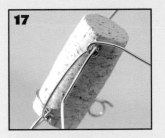

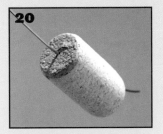

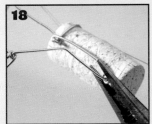

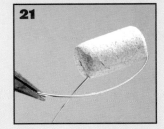

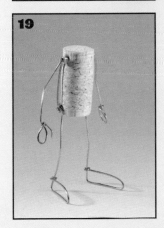

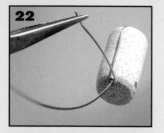

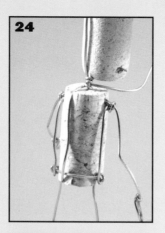

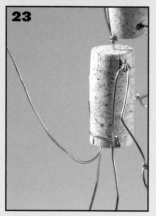

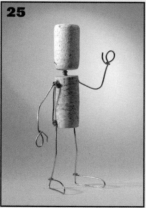

22. Wind this end of the wire tightly around the longer end where it emerged from the cork, and cut off the extra.

23. With the remaining long wire end, work it through the length of the body's cork. Pull most of it through, just leaving a bit for the neck.

24. Bend this wire up toward the neck, making it tight to keep it close to the body. Wrap around the neck and cut off the extra. Now your cork body is bound on three sides—and unless your "neck" is too long, the head should stay in place.

25. Finished!

26. Using a marker, make a face for your character if you like.

27. Or find some small wood screws, and washers and make a robot (this one looks like a sleep-walking robot zombie to me.) I made the gouge for this fella's mouth courtesy of a standard screwdriver.

28. Here, I threaded a wire through the hinge of a clothes-pin, wrapped it around the wooden part a few times, and connected it to the body just like a cork head. It looks a little menacing, but would be a good message holder!

29. This variation proves that two heads are more interesting than one! The eyes are eyelets often found in craft stores and used by scrapbookers; they are held in place by pins with colored heads. As the pins stick out the back of the head, bend those ends back into the cork with your pliers, so they hold the eyelets in place and don't poke anyone.

Or use other small objects to create your own variations. Have fun!

—T.B.

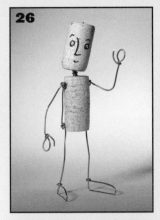

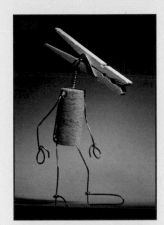

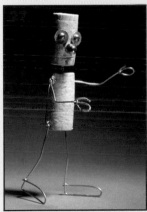

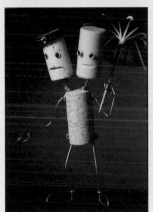

ABOUT THE AUTHOR

Terry Border was born with a slightly twisted perspective toward life in 1965. After spending over forty years wandering around and bumping into things, he seems to have finally found a use for his odd view (finally!!), and (for lack of better term) he calls it "art." Most days, he's happy spending his time creating it in a little house, which he shares with his patient wife, his growing daughter, two cats, and some fish.

Please visit him at www.bentobjects.blogspot.com.

I would like to thank everyone who has visited my site over the years, especially those who regularly leave comments. Your attention and encouragement are two crucial ingredients in my blog's success.

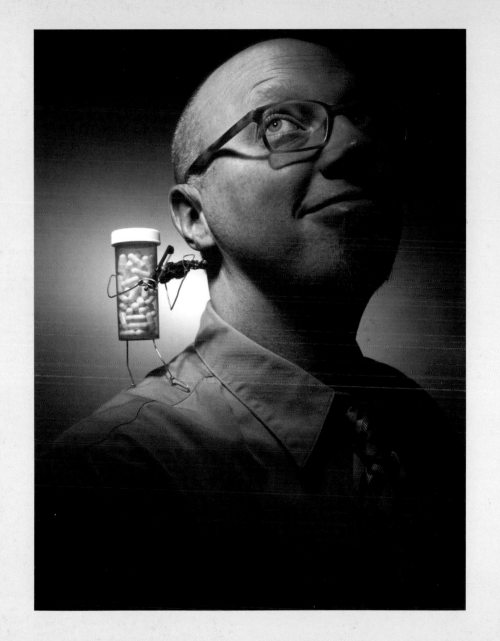

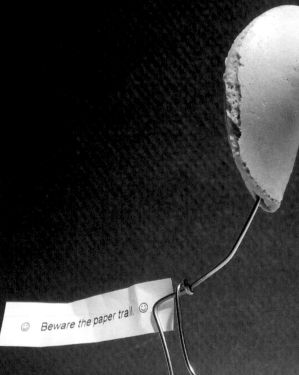

Unfortunate

☺ Beware the paper trail. ☺